2002
Photographs of
Thailand and Cambodia
by Tara Jan Parekh

Photography Copyright © 2002 by Tara Jan Parekh
Text Copyright © 2008 Tara Jan Parekh

All rights reserved. No part of this work may be reproduced in any form without written permission from the publisher.

The copyright on each photograph in this book belongs to the photographer, and no reproductions of the photographic images contained herein may be made without the express permission of the photographer.

Published by Lulu.com

ISBN 978-0-578-00300-9

Photography, Text, and Book Design by Tara Jan Parekh.

ABOUT

During the summer of 2002, I traveled to Thailand and Cambodia. This book showcases a selection of photographs taken throughout my visit. Please enjoy!

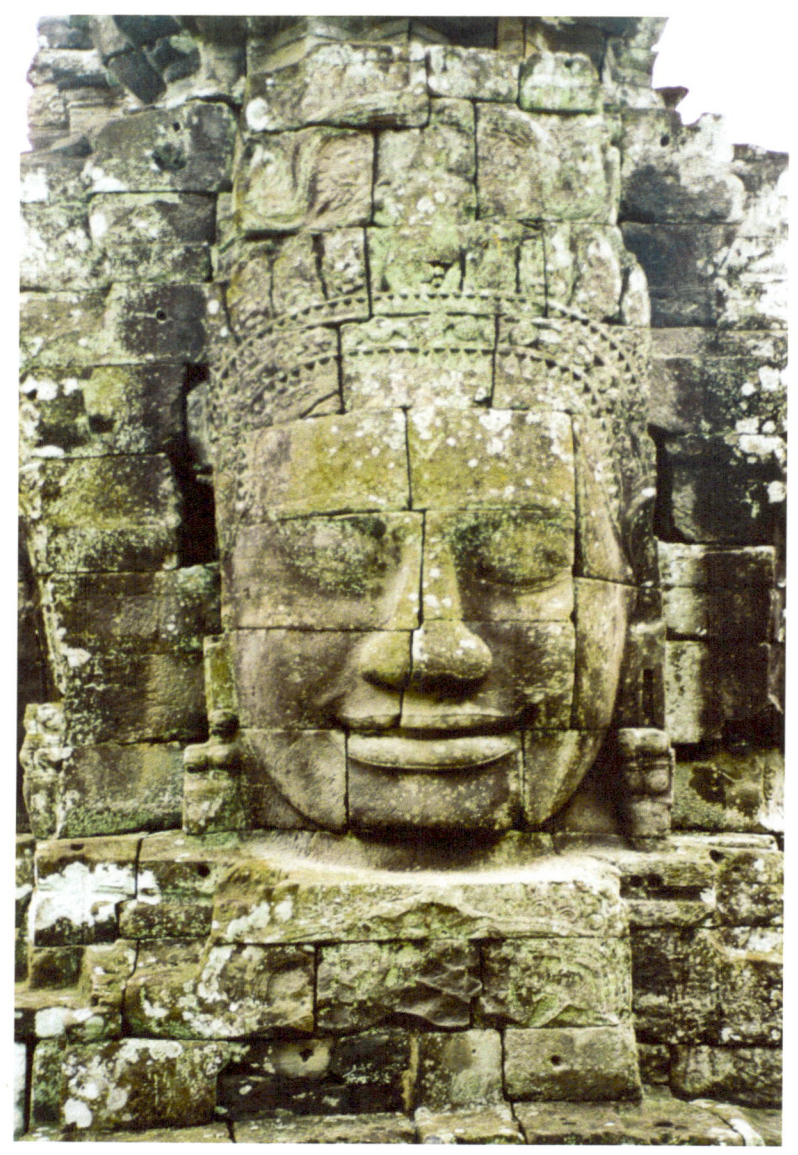

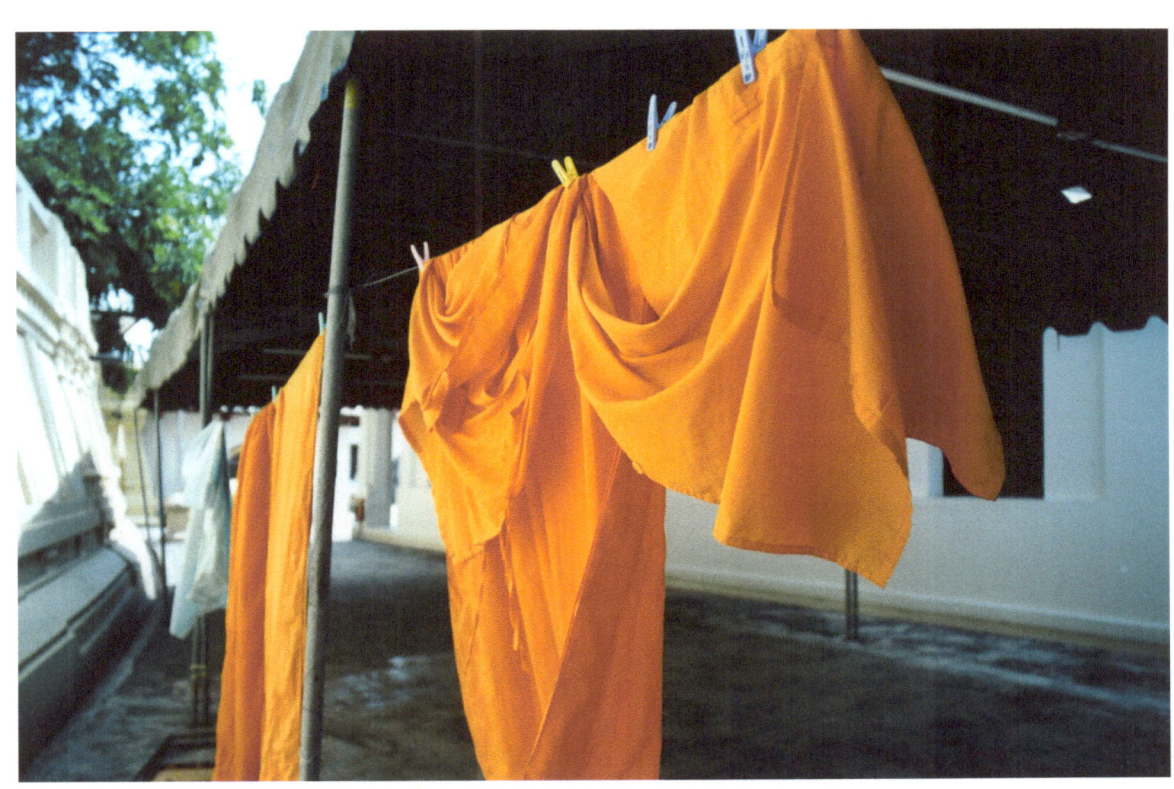

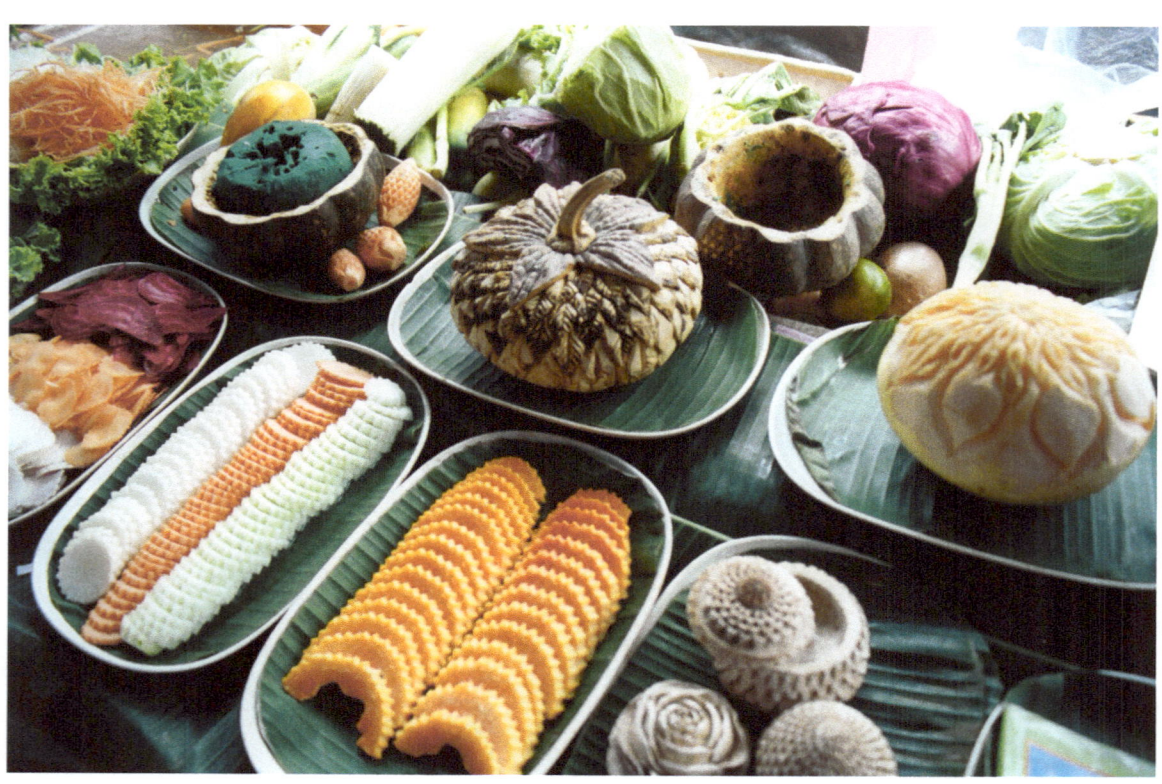

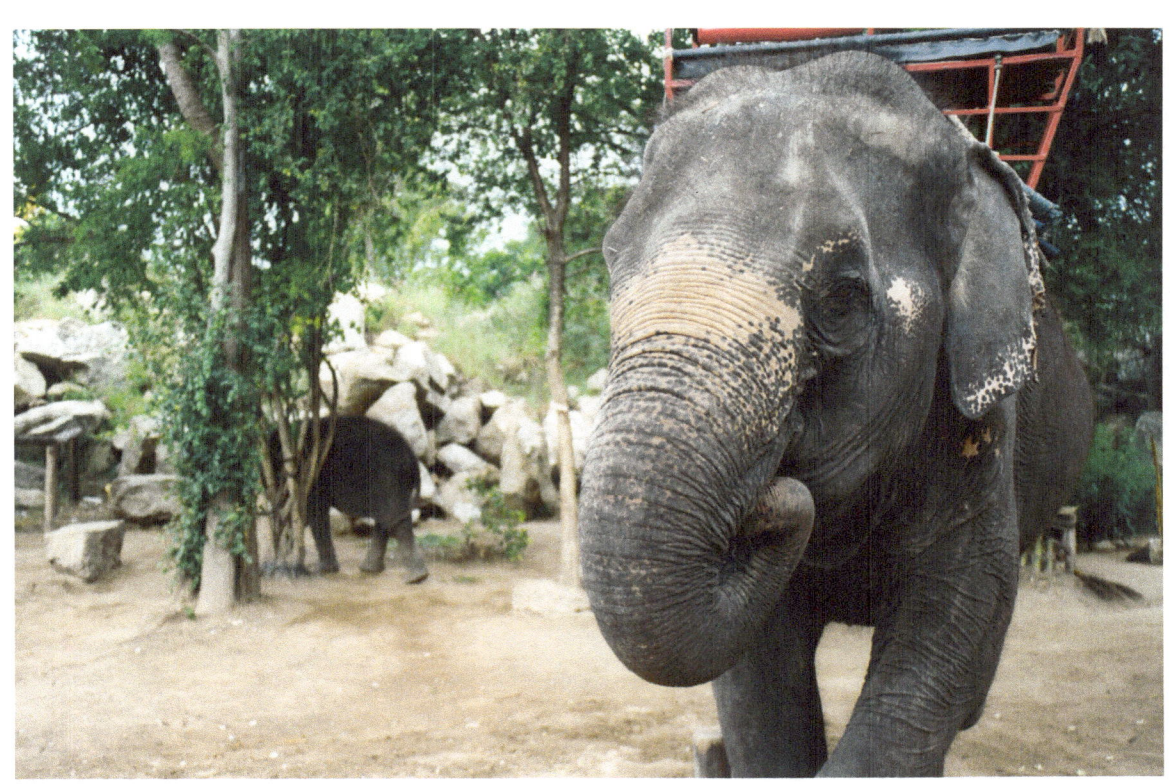

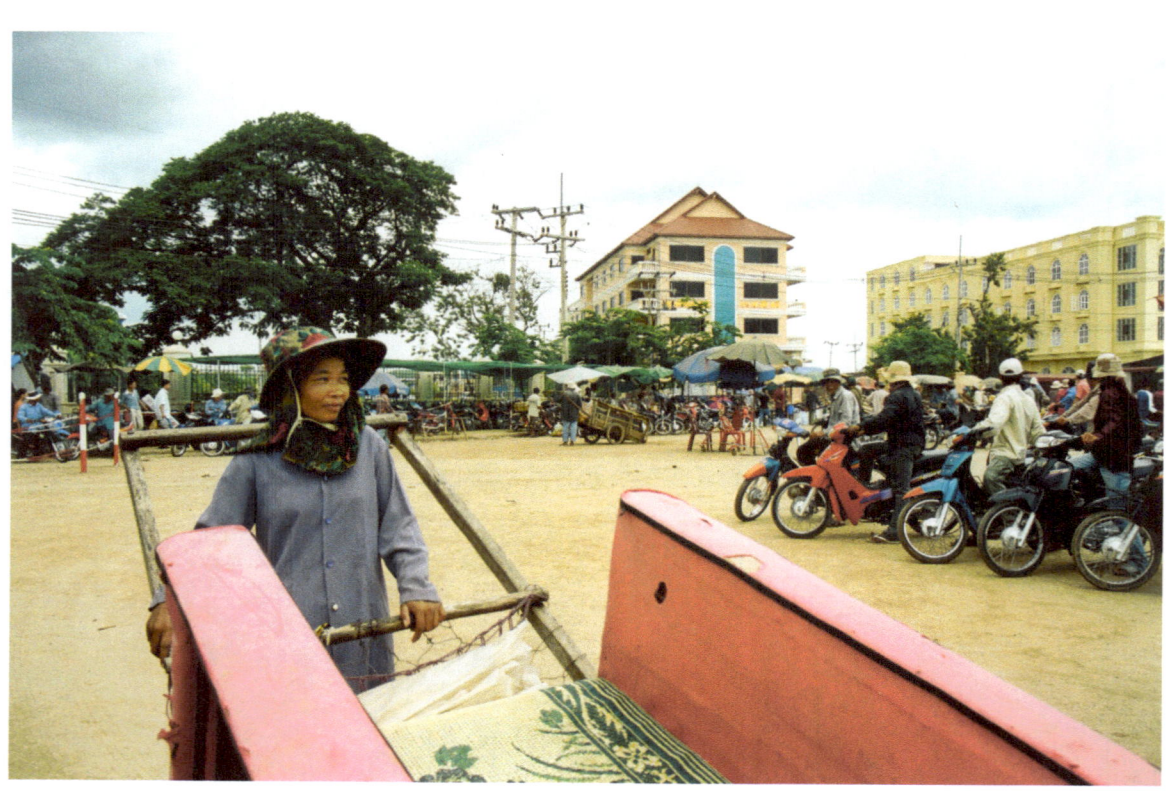

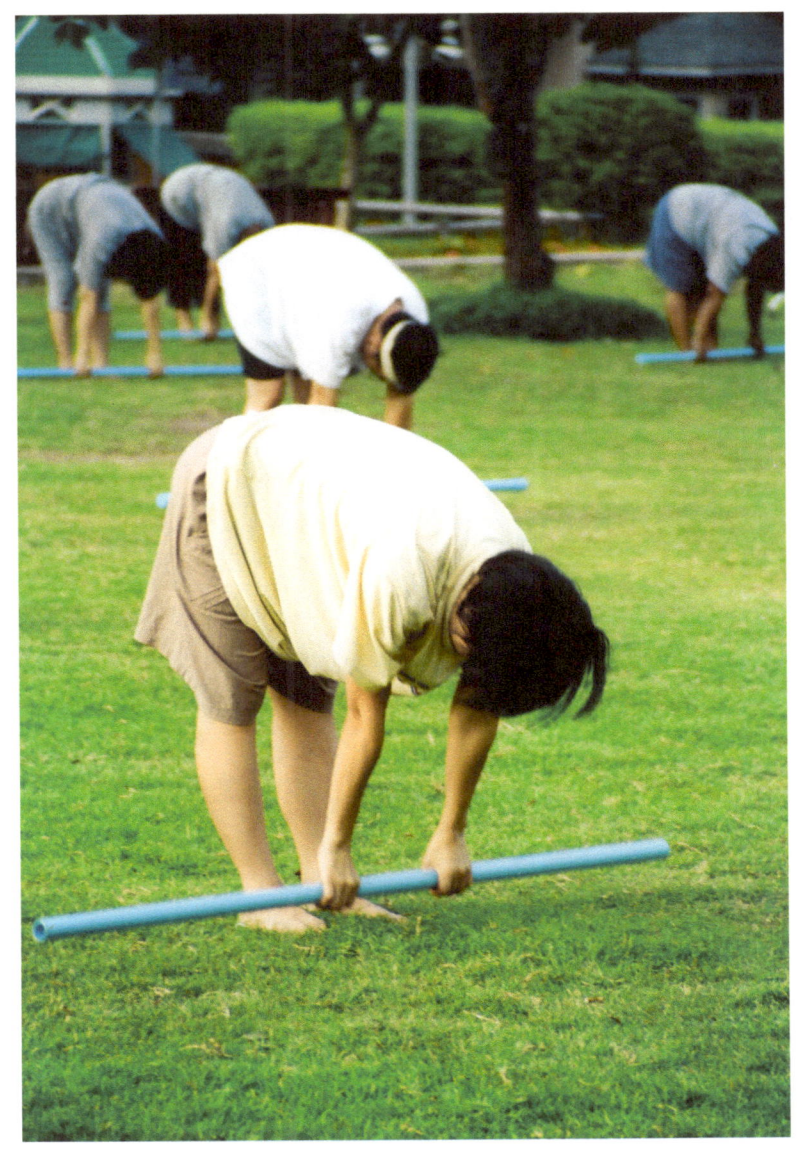

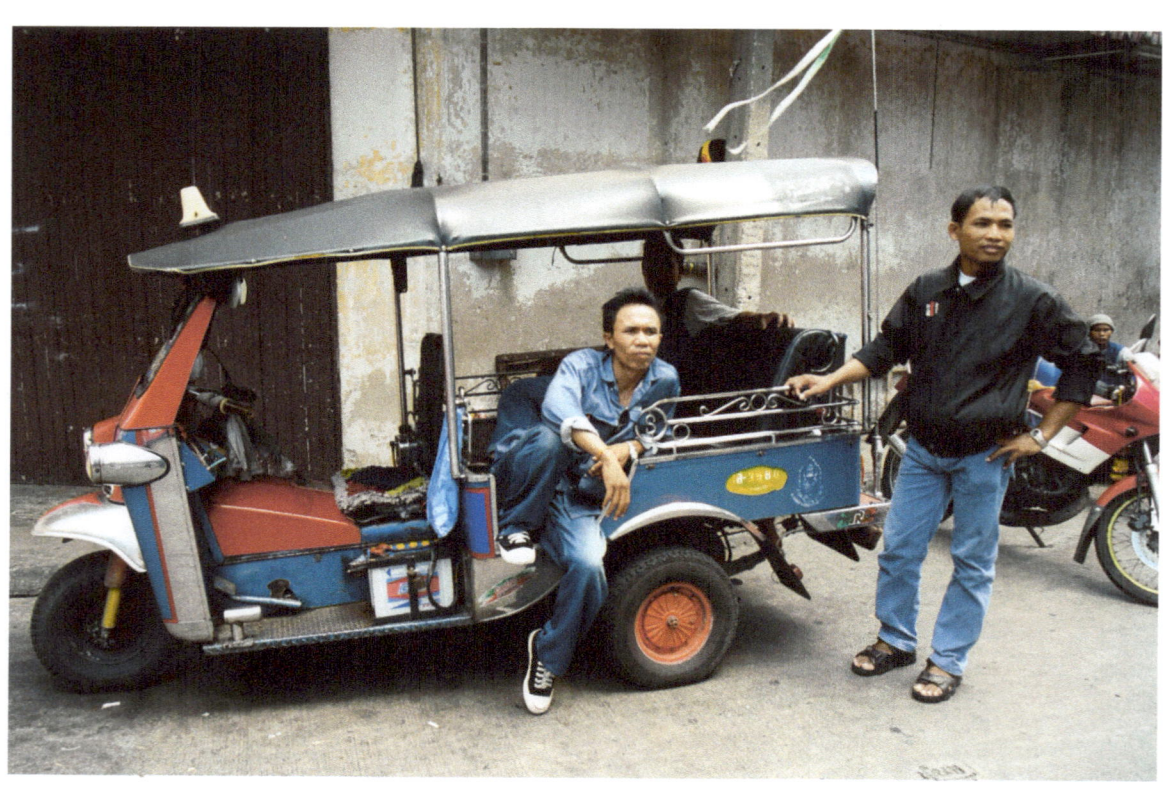

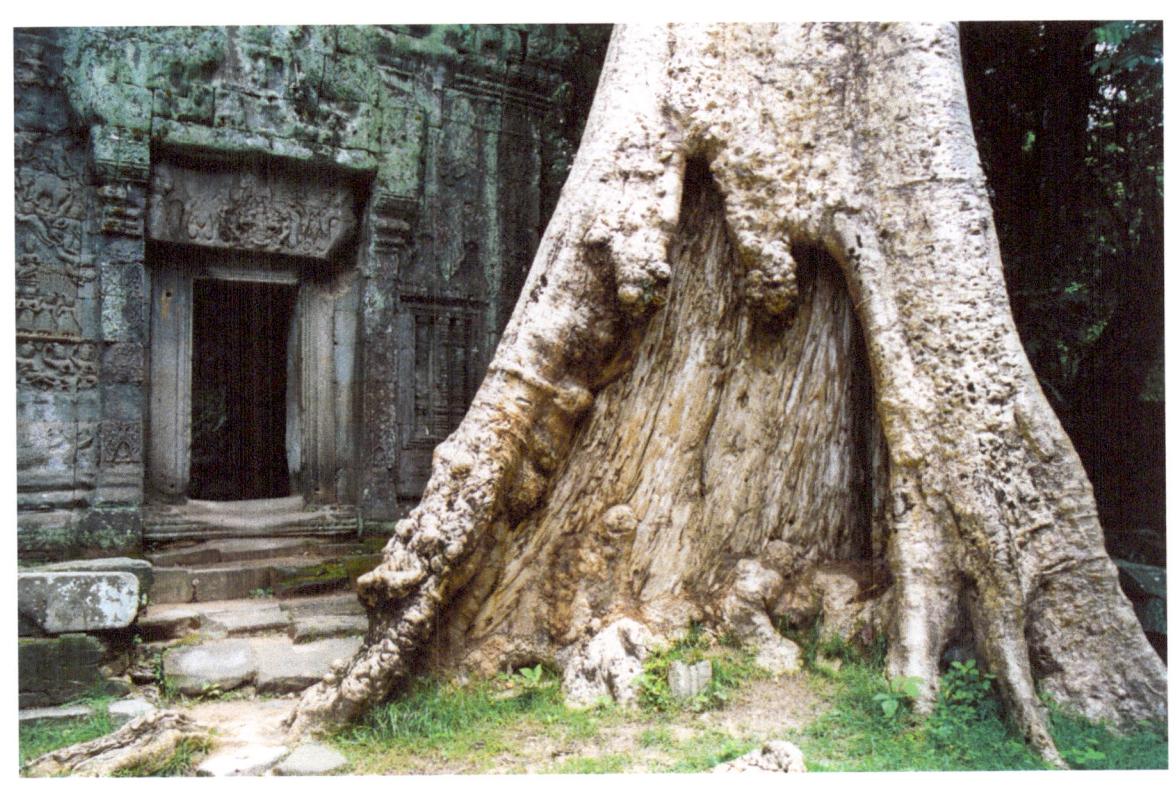

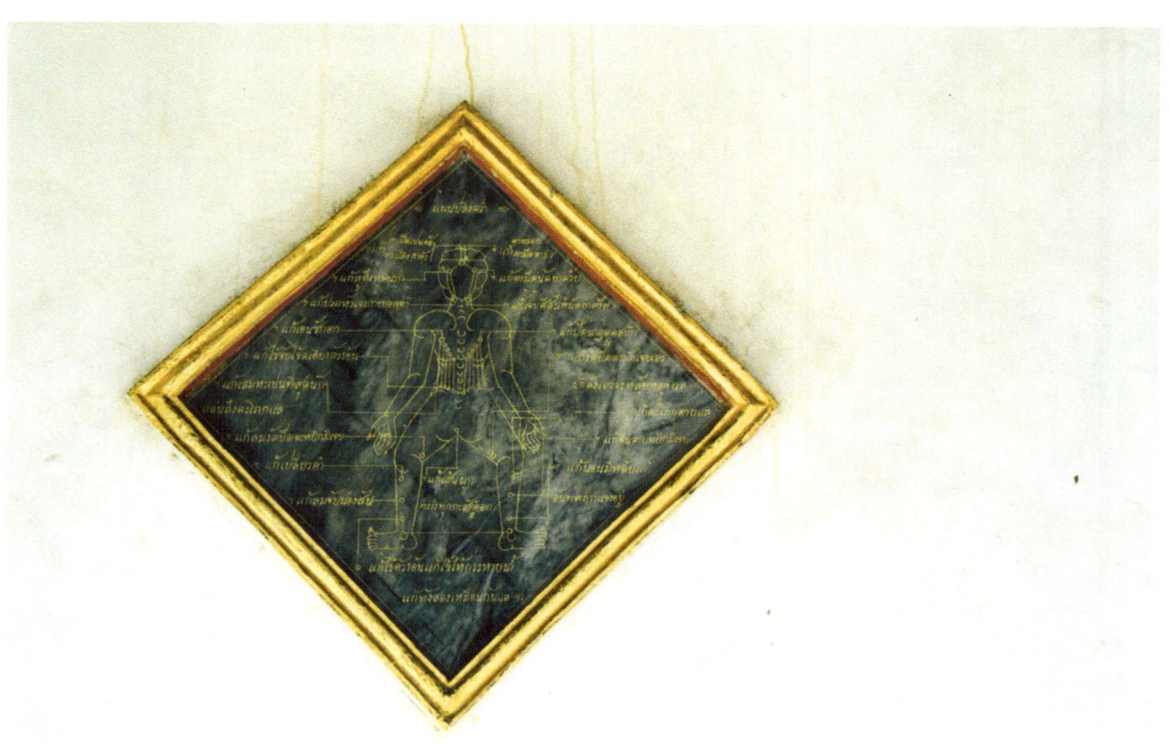

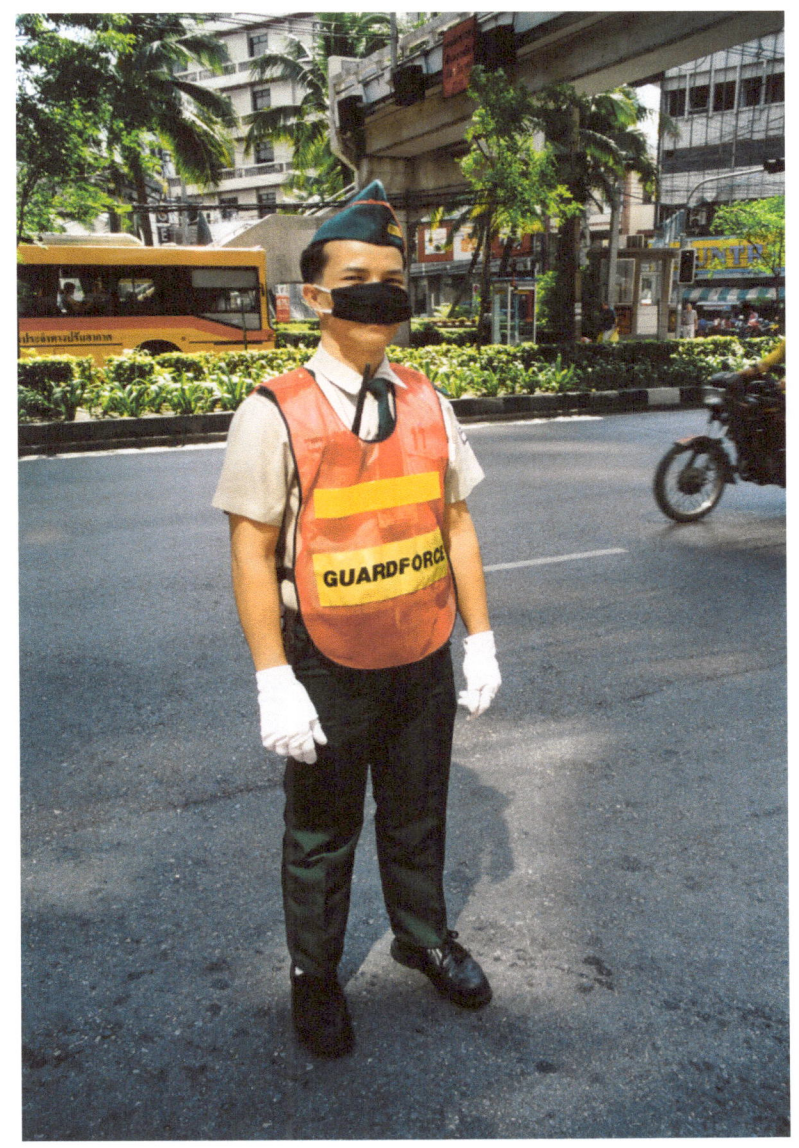

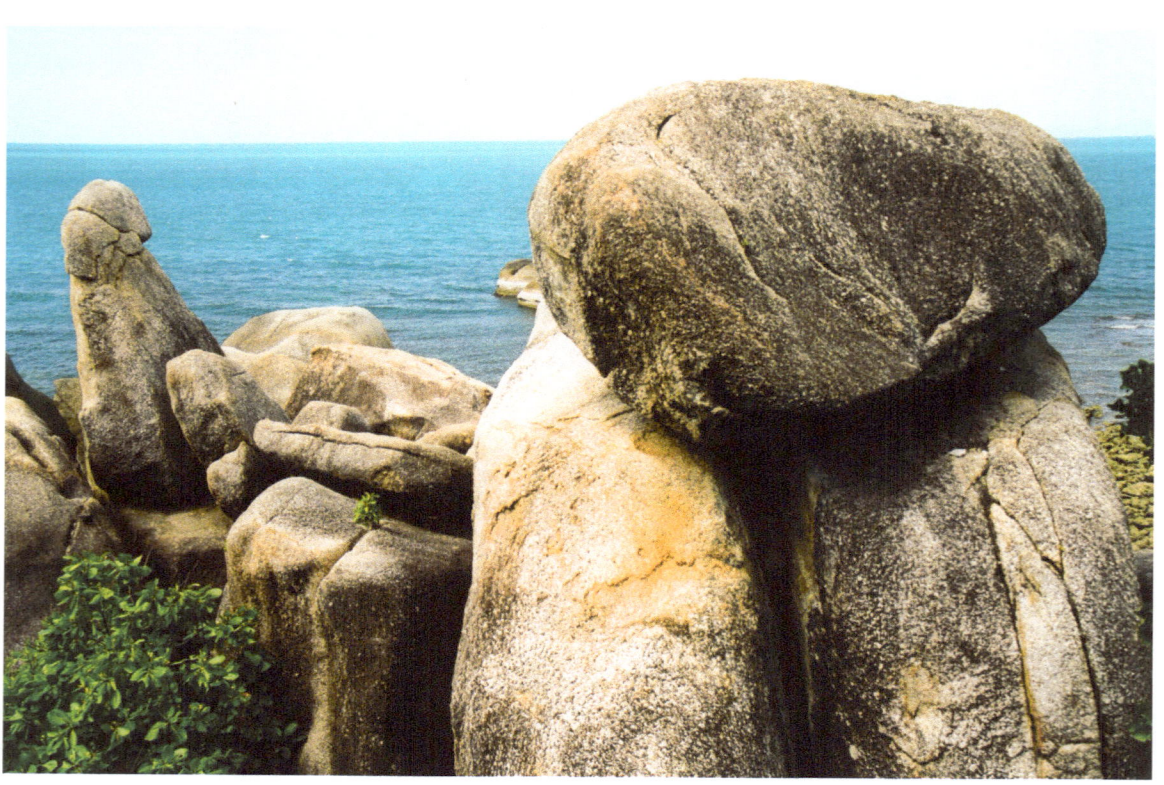

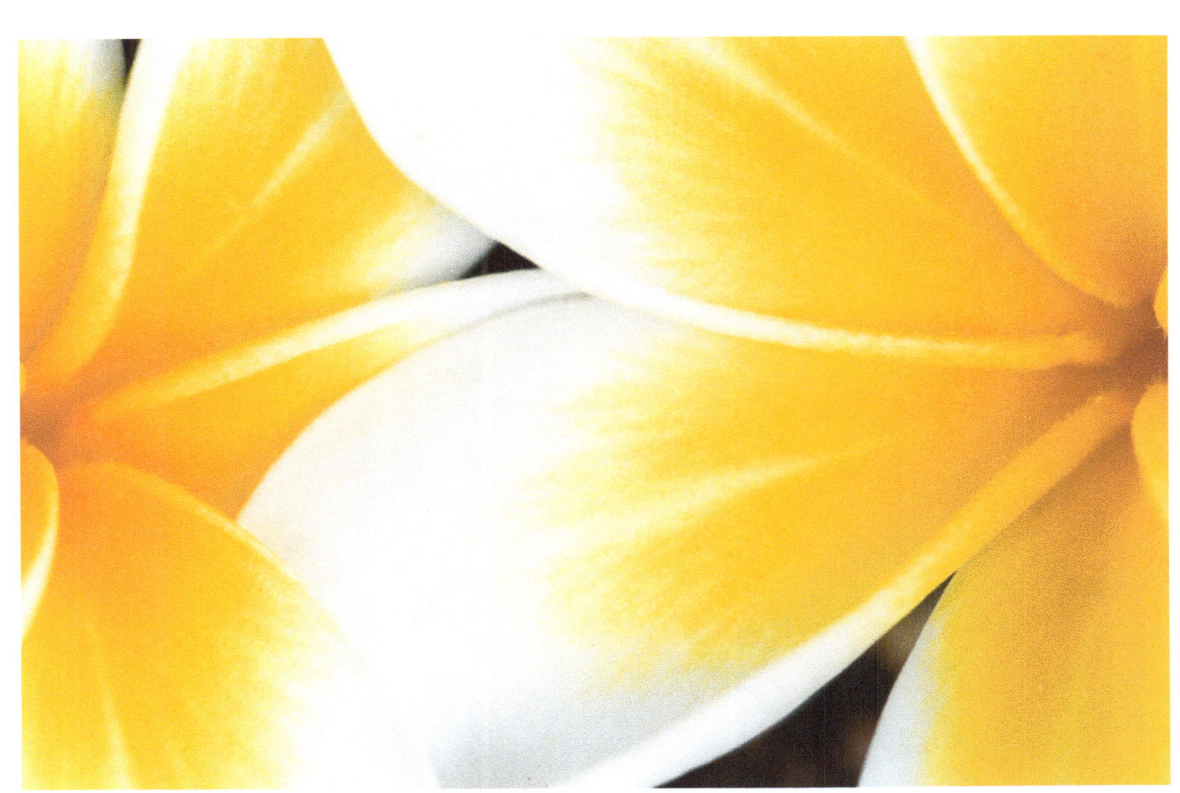

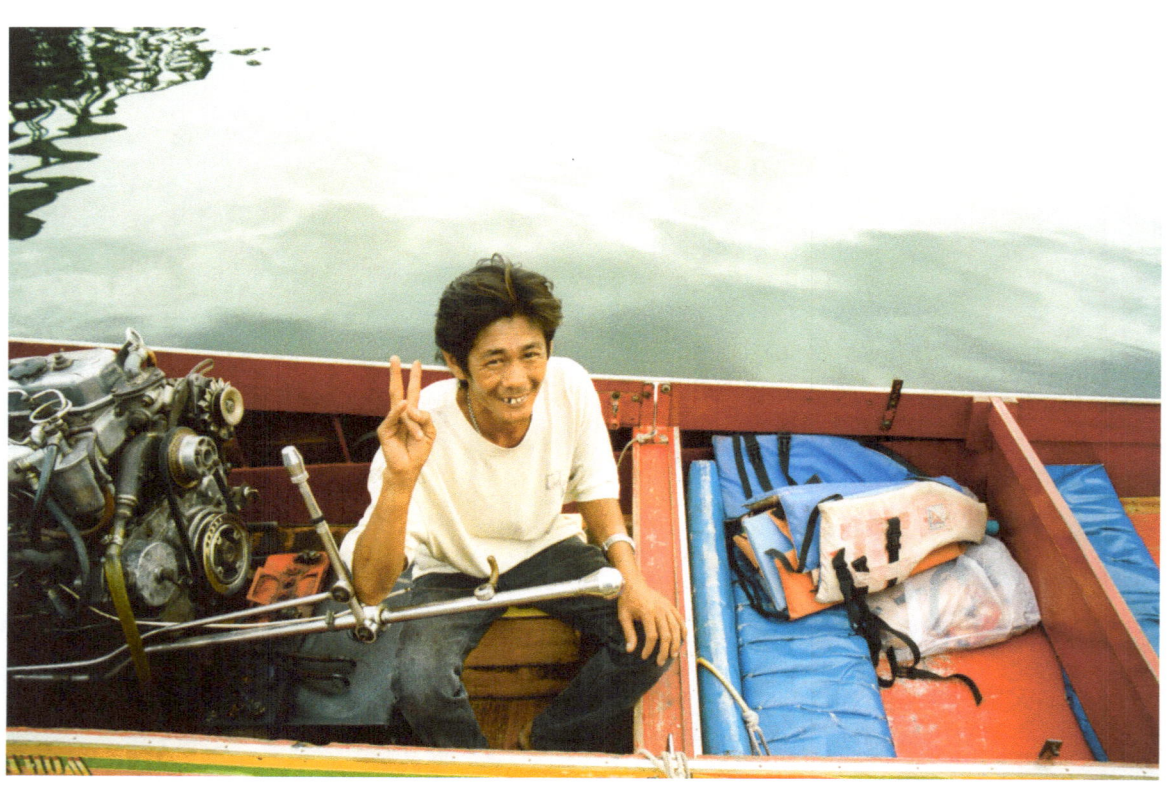

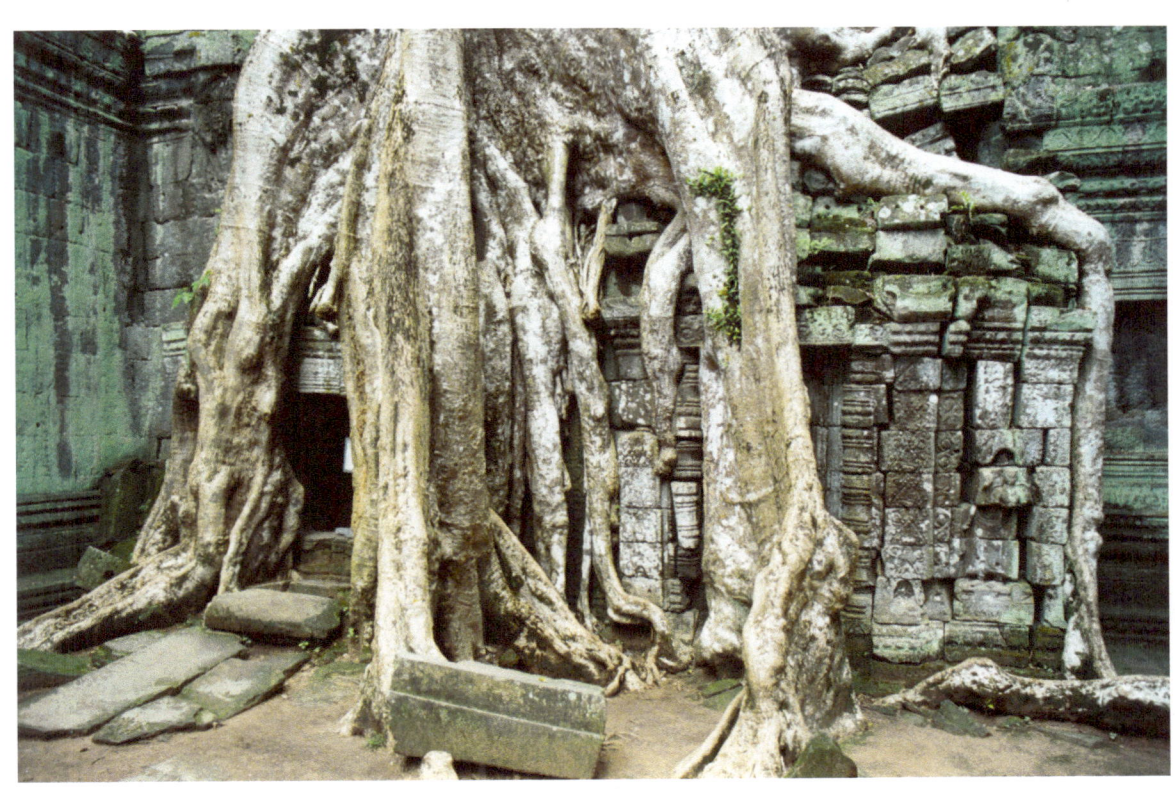

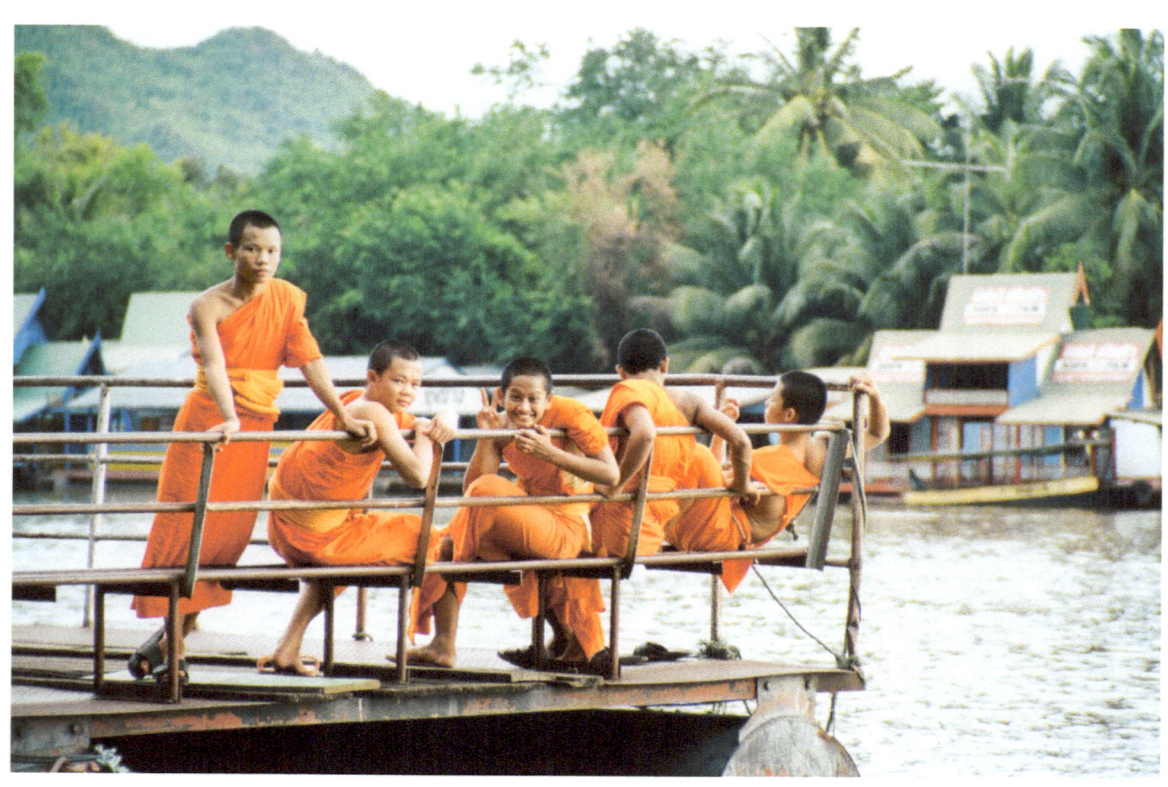

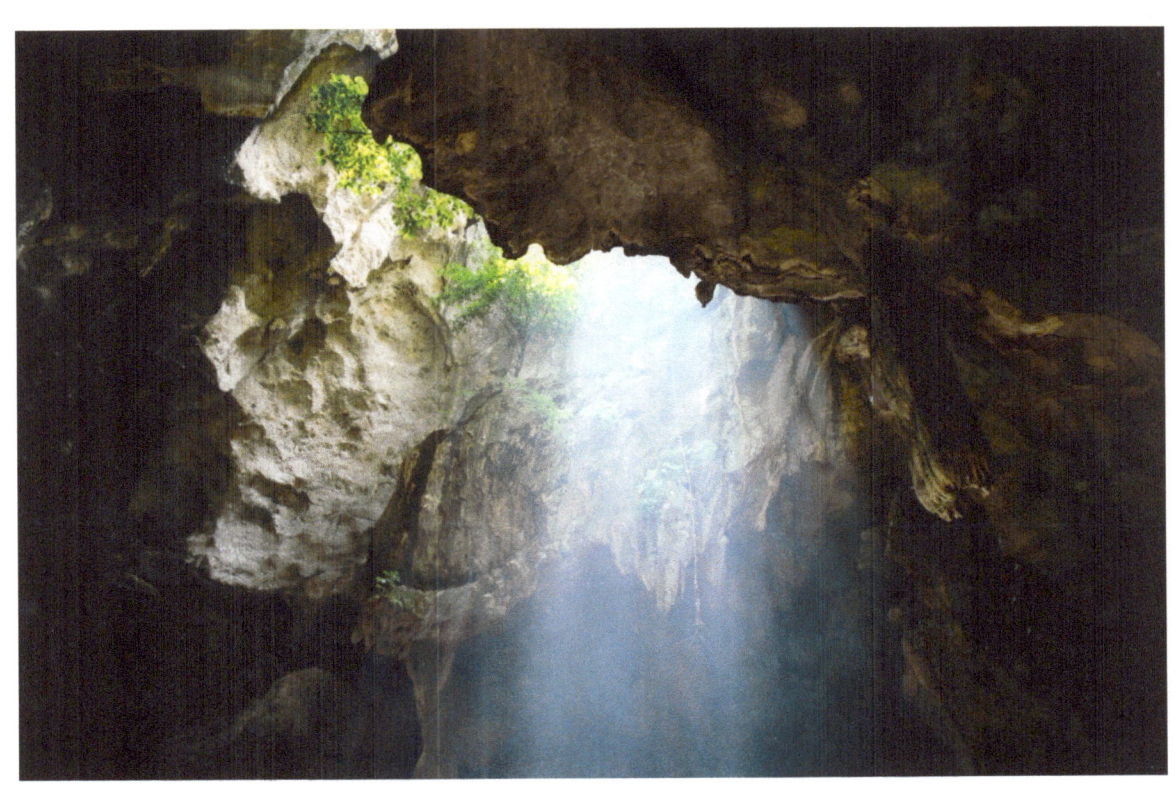

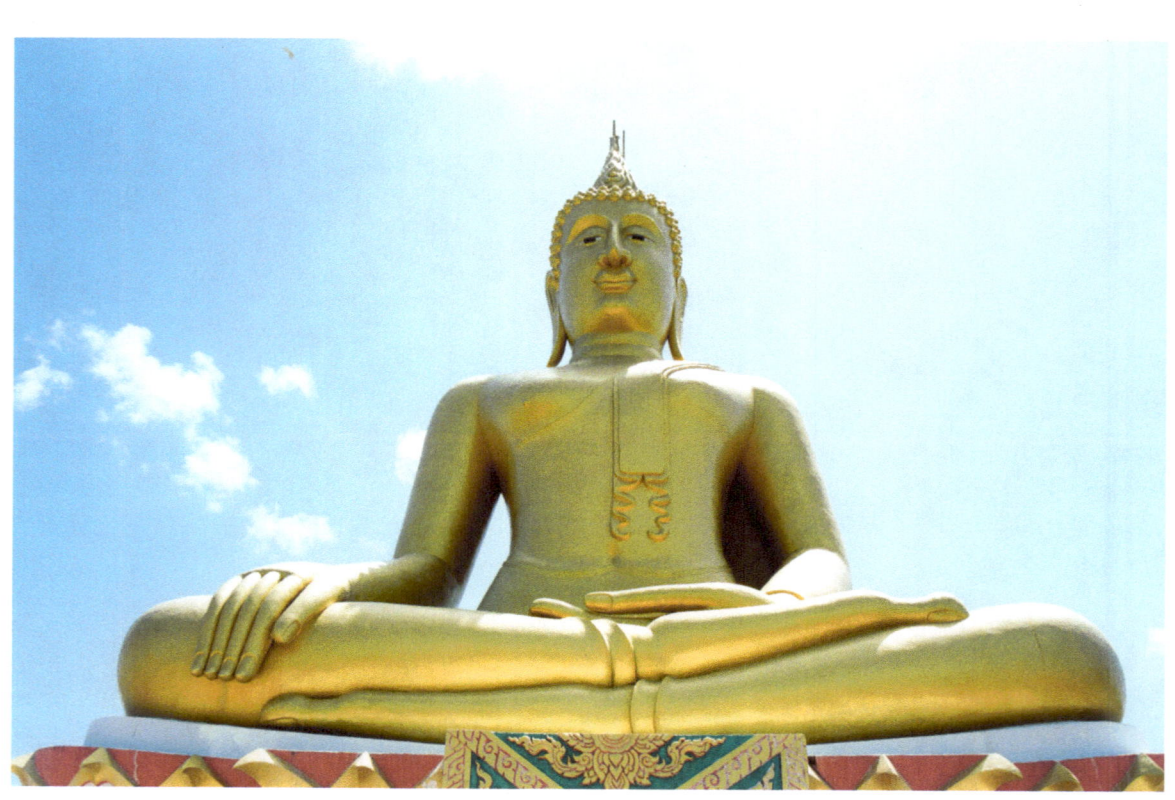

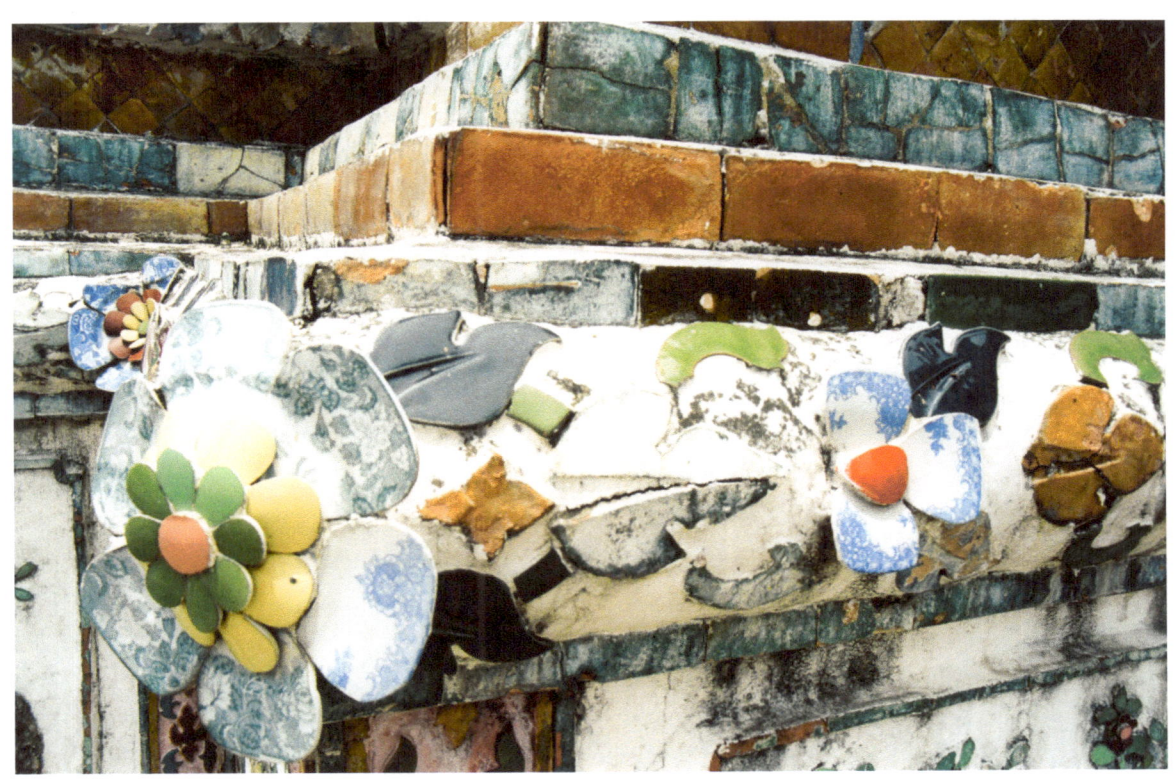

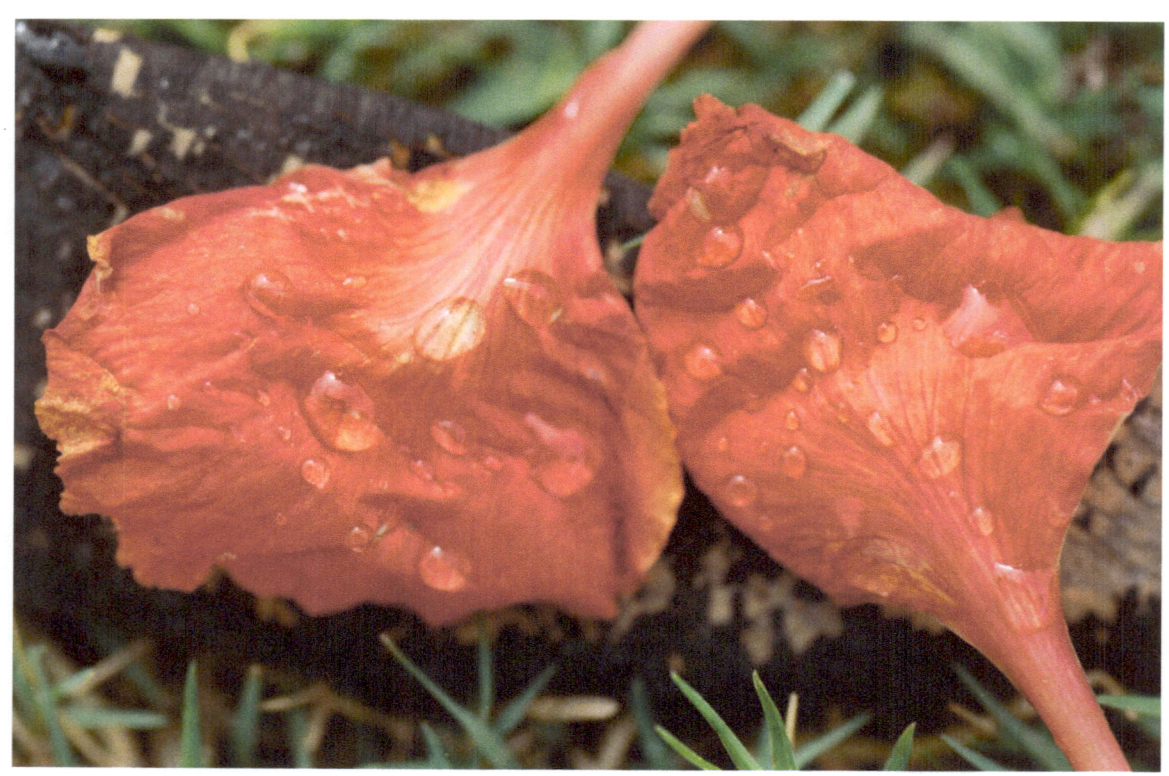

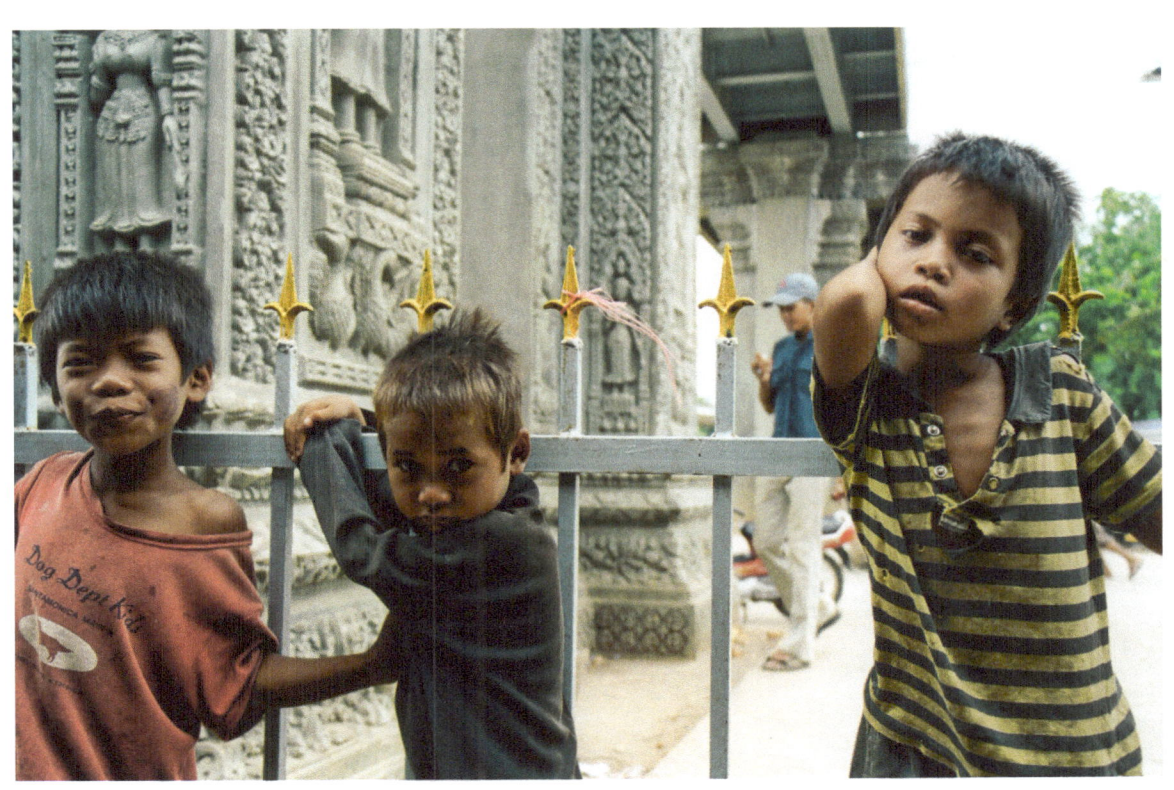

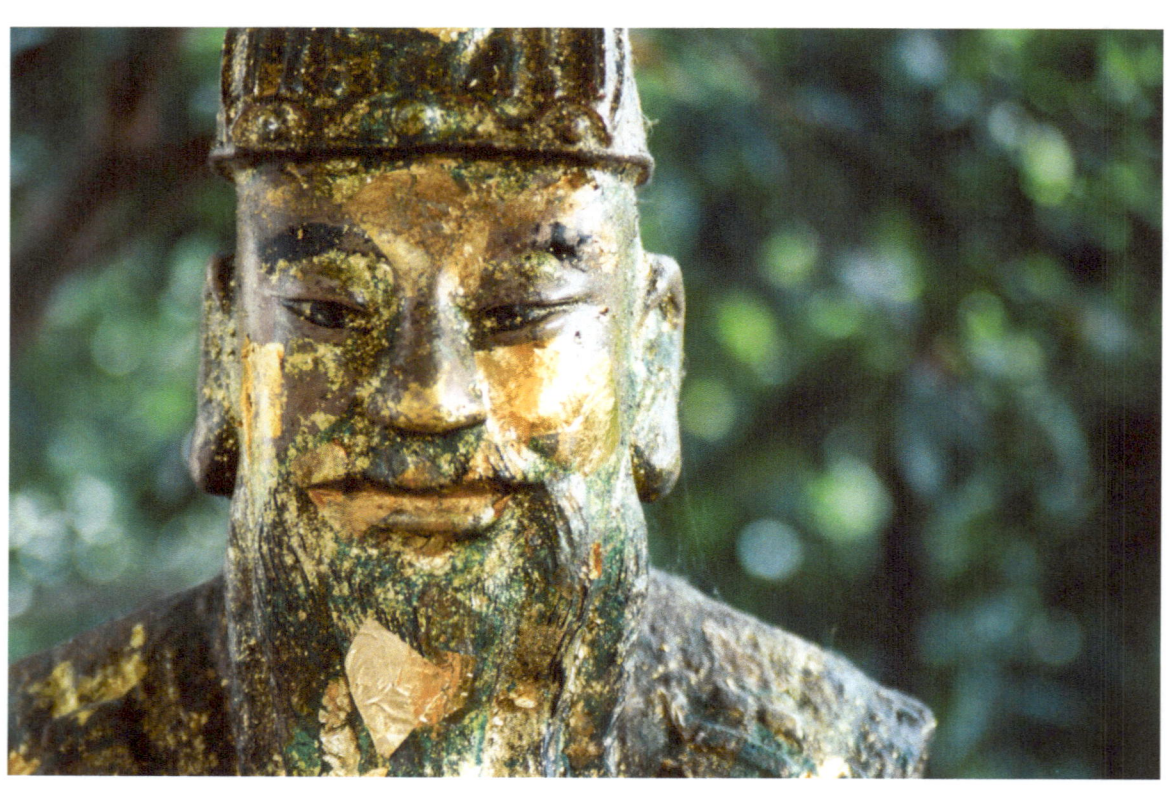

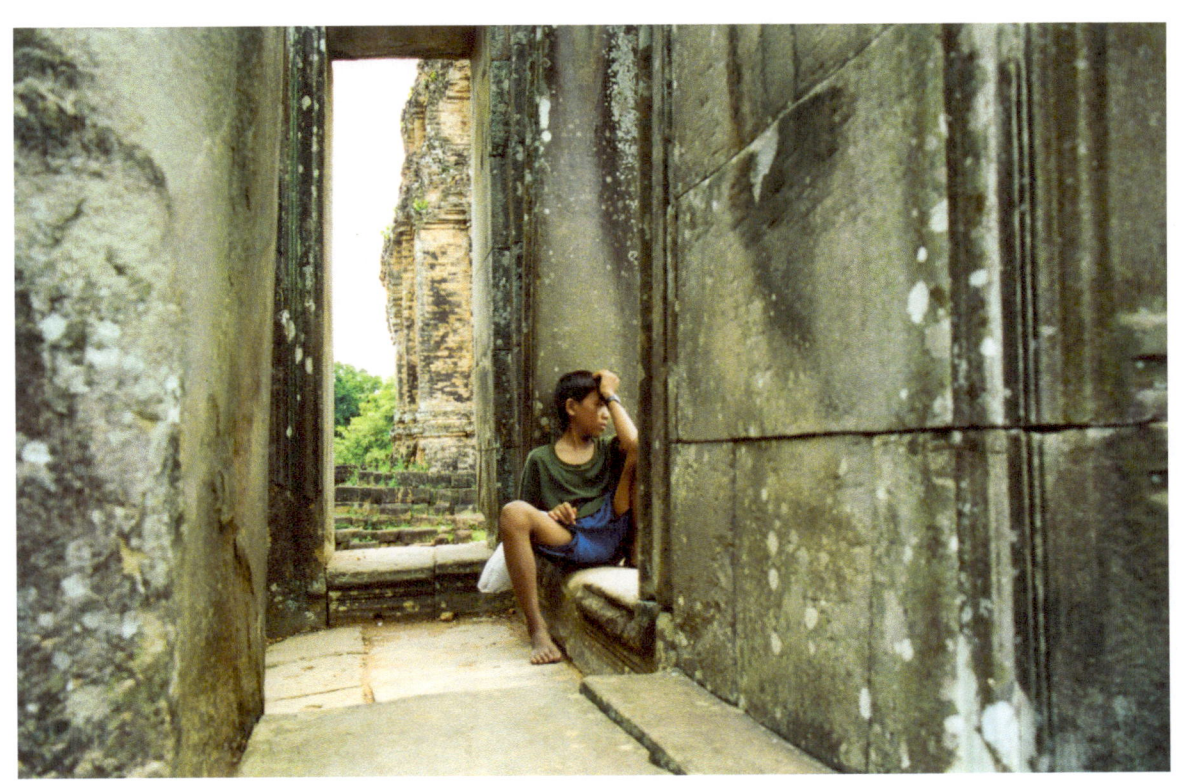

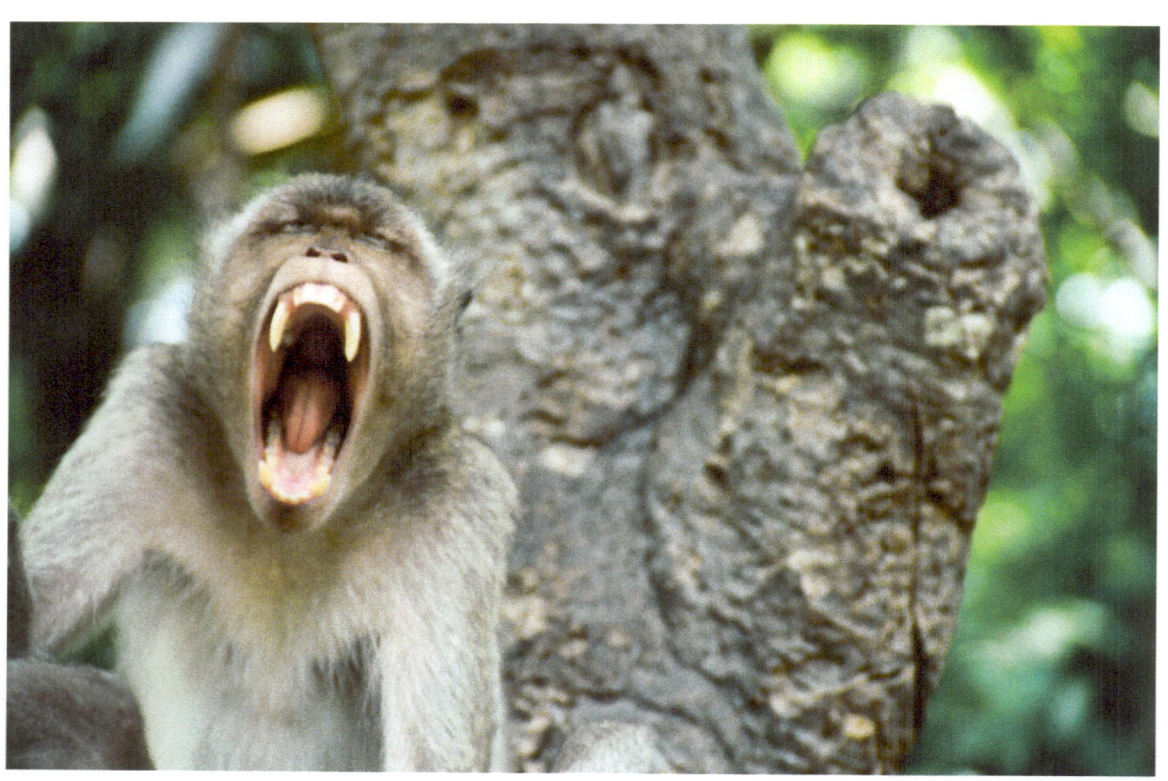

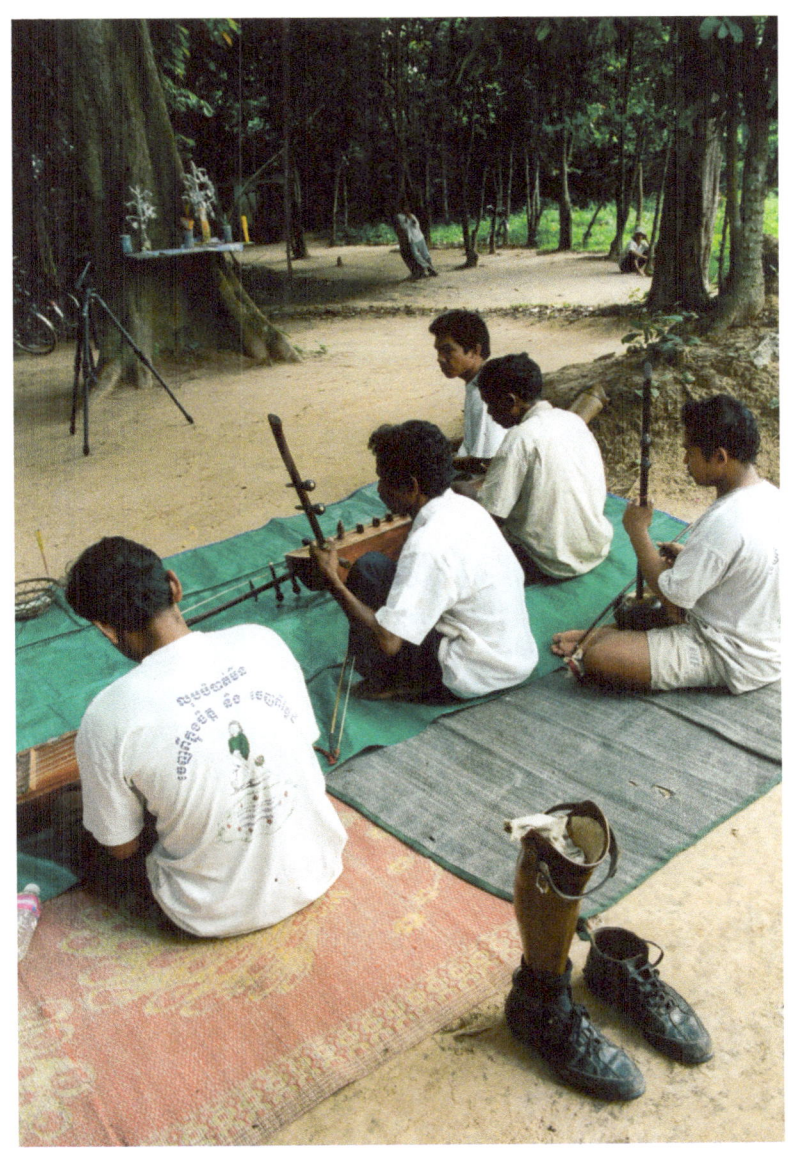

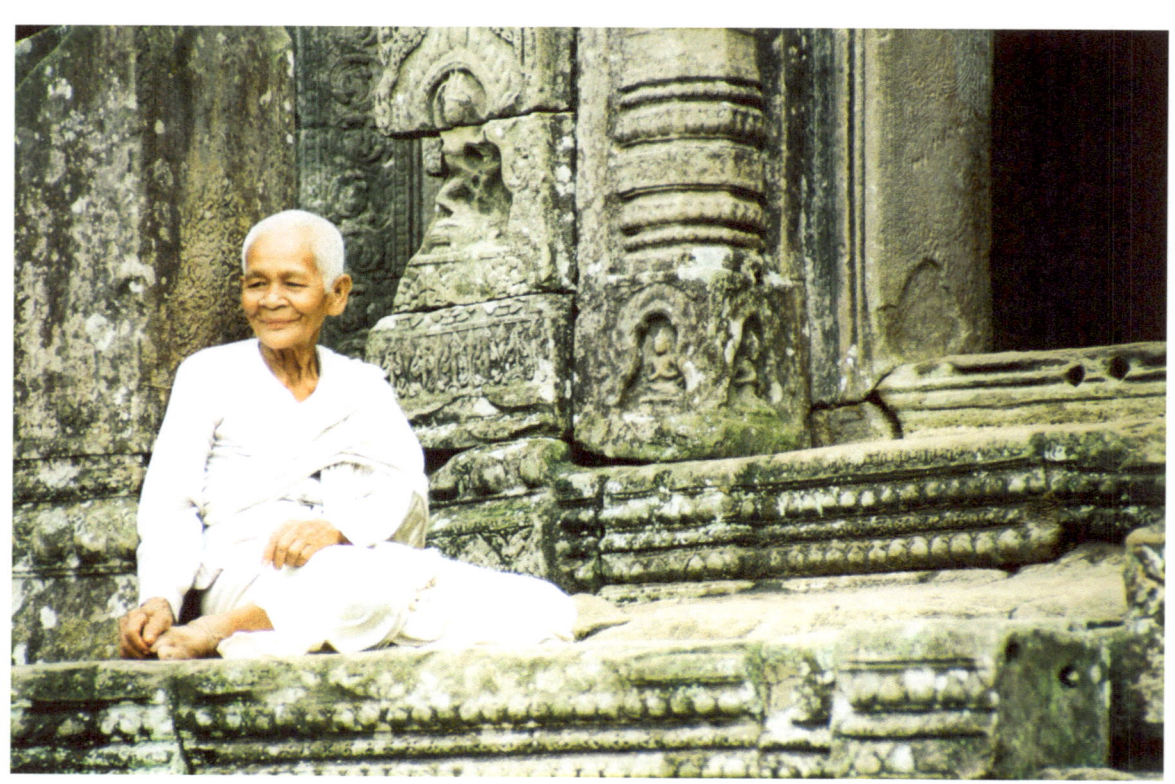

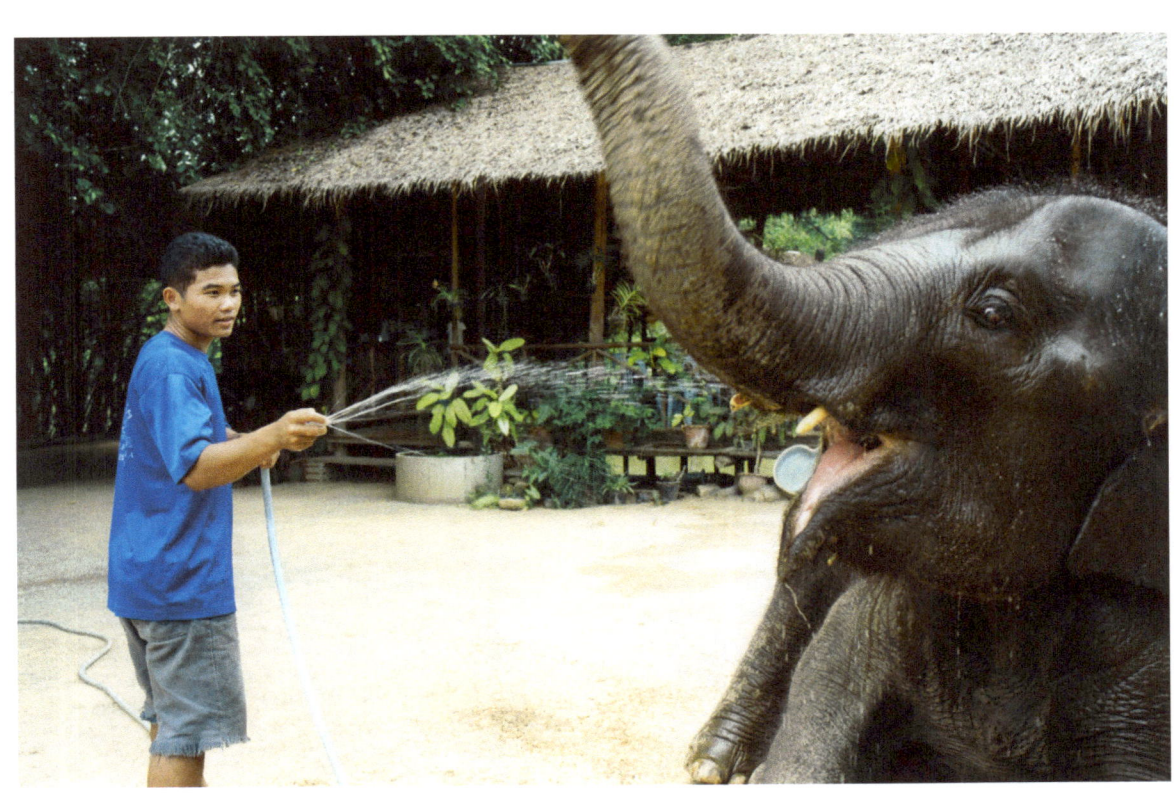

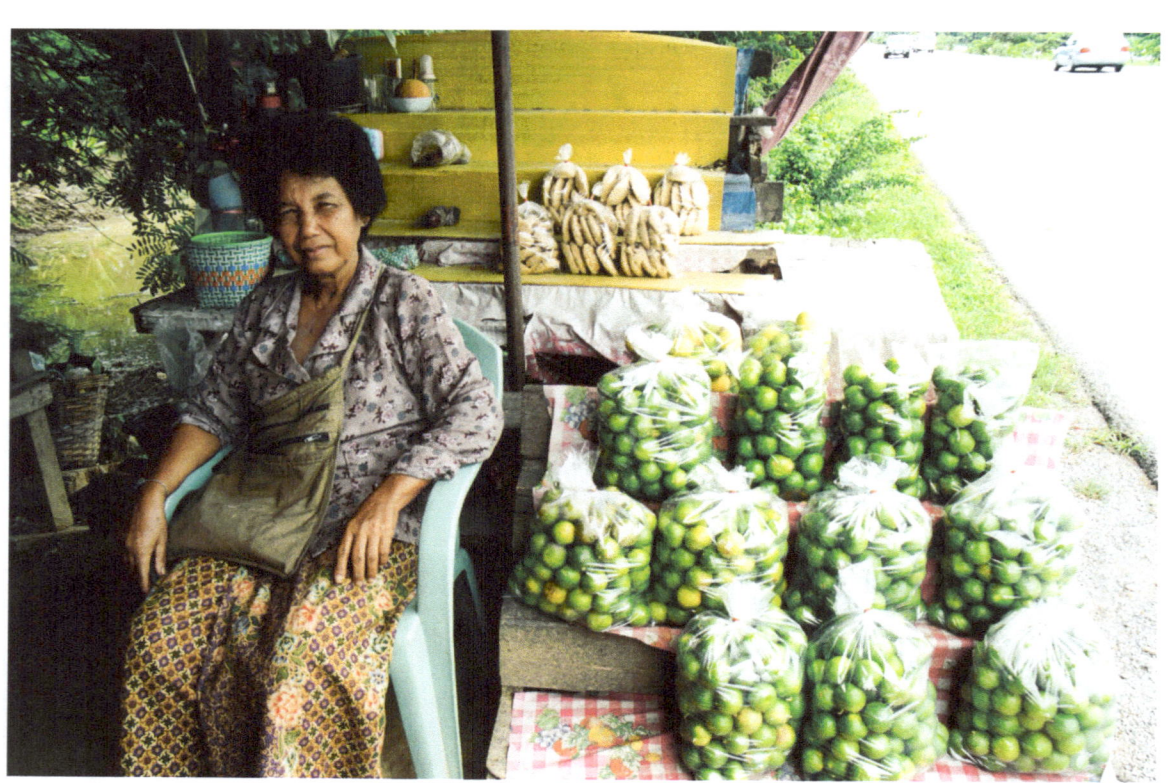

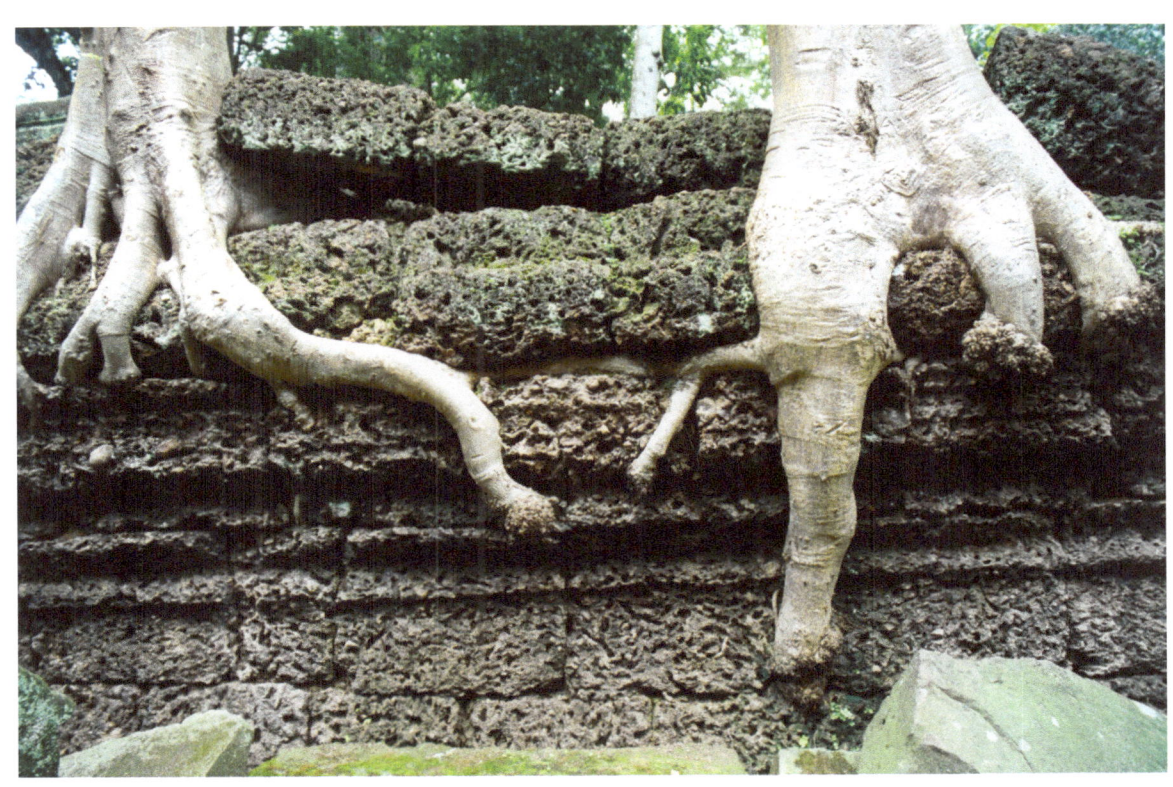

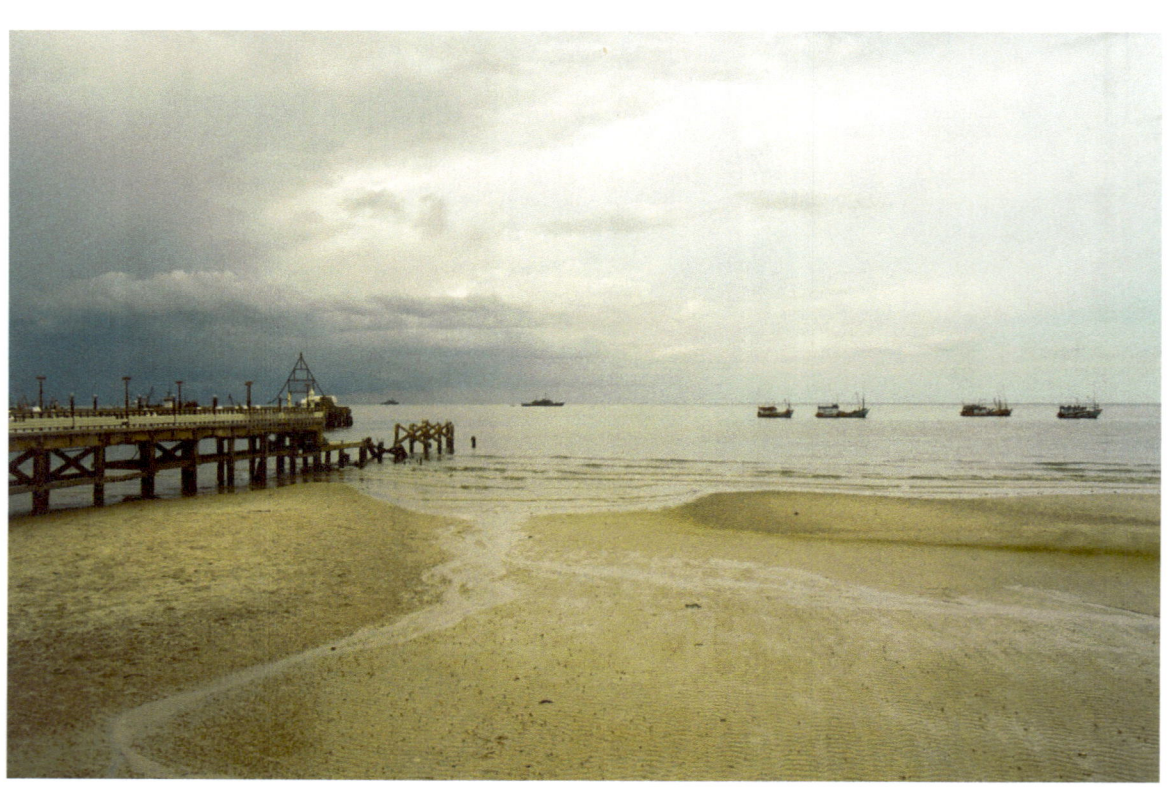

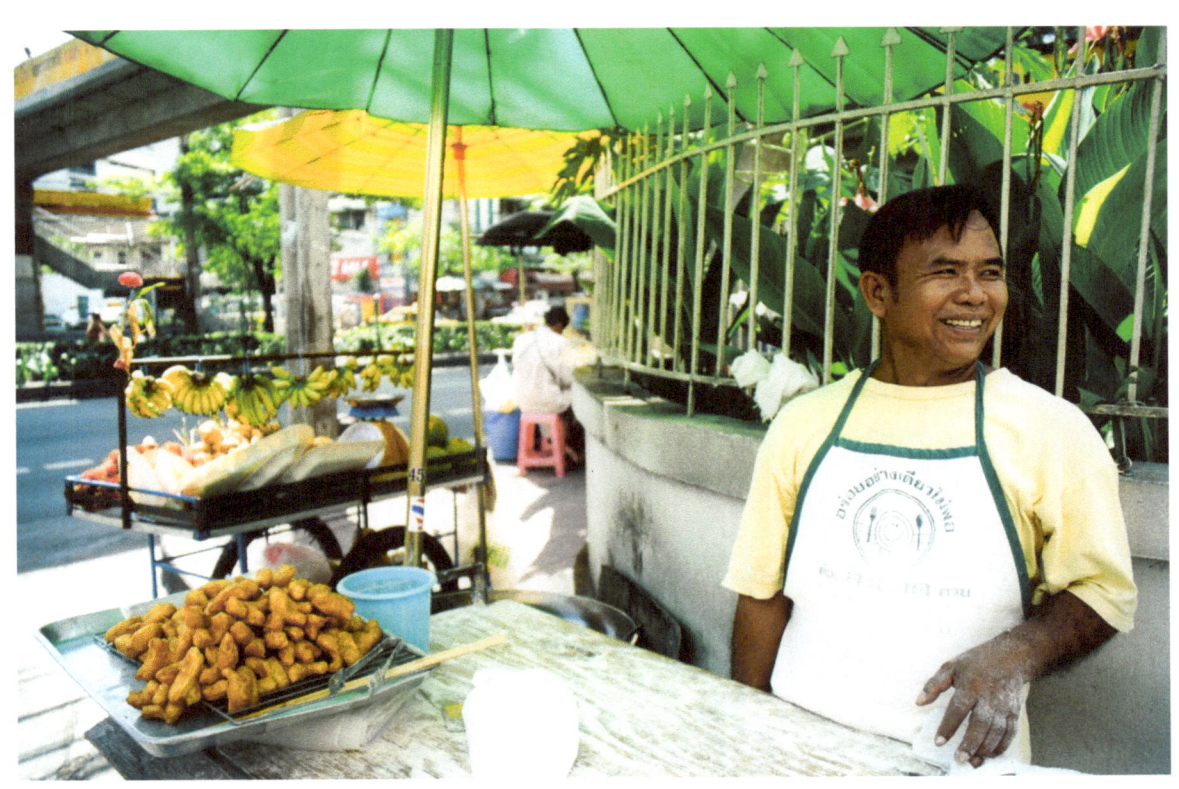

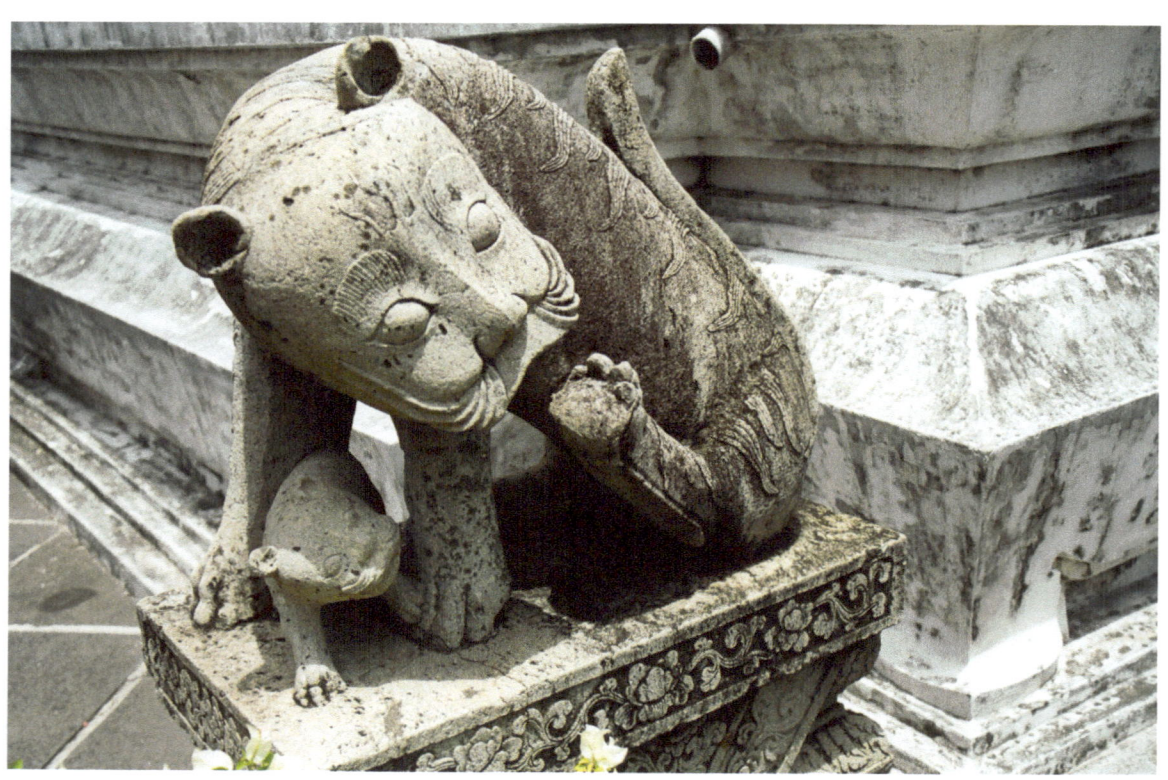

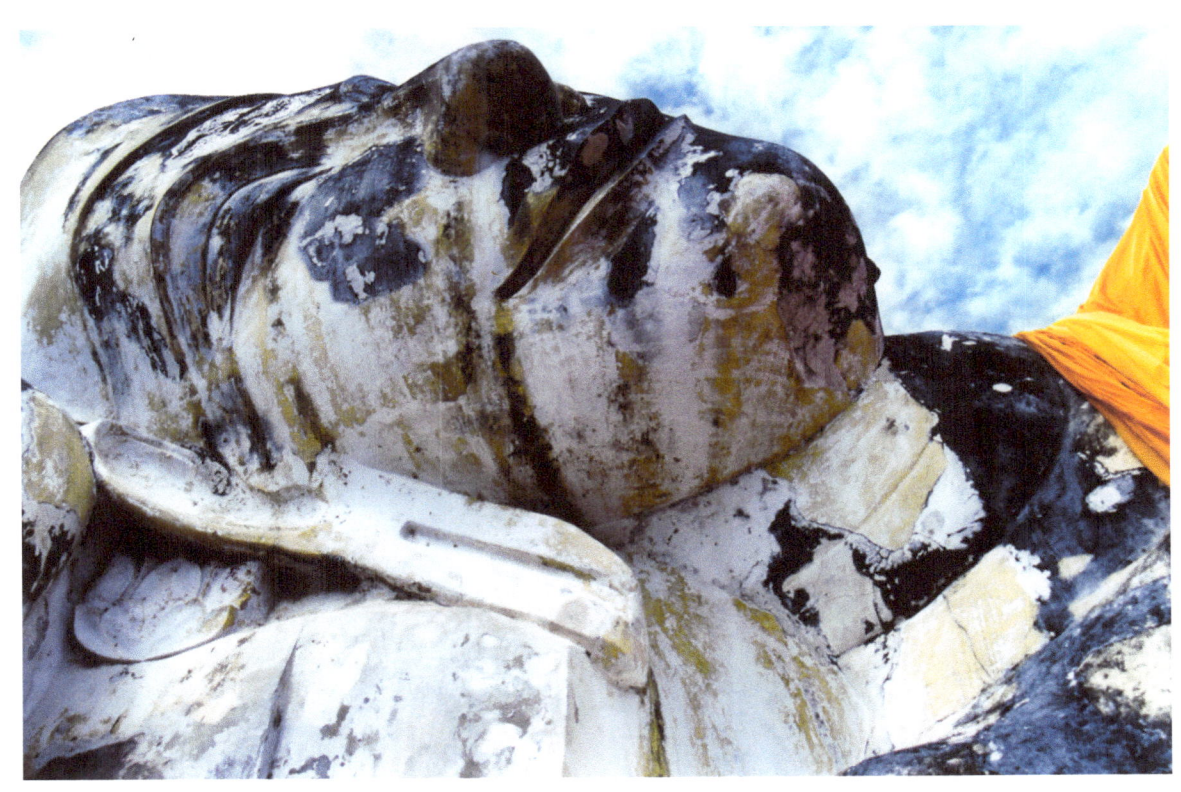

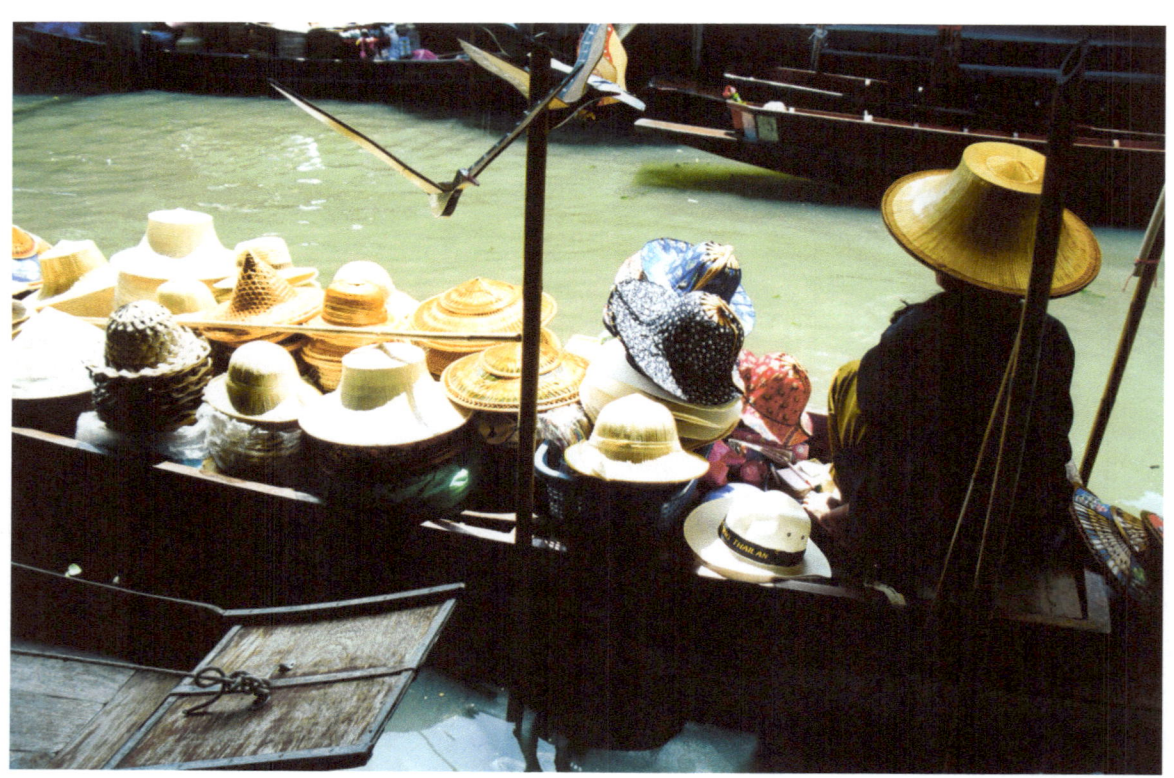

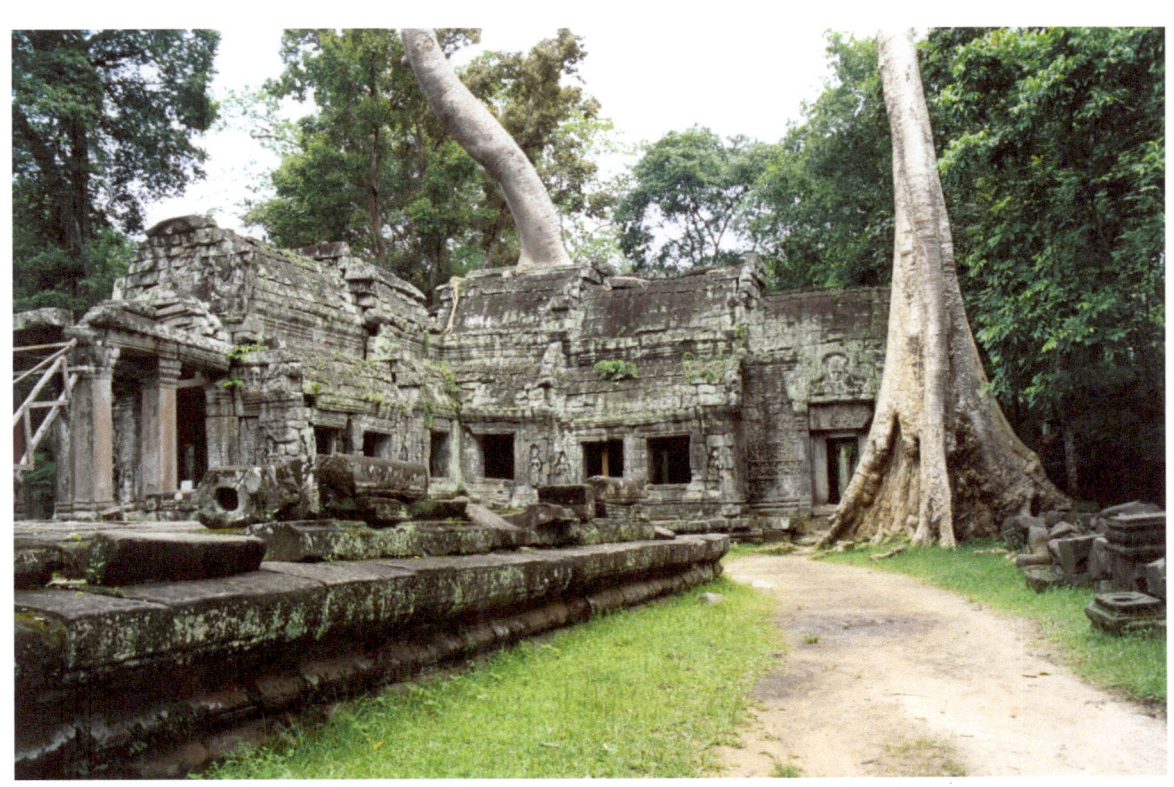

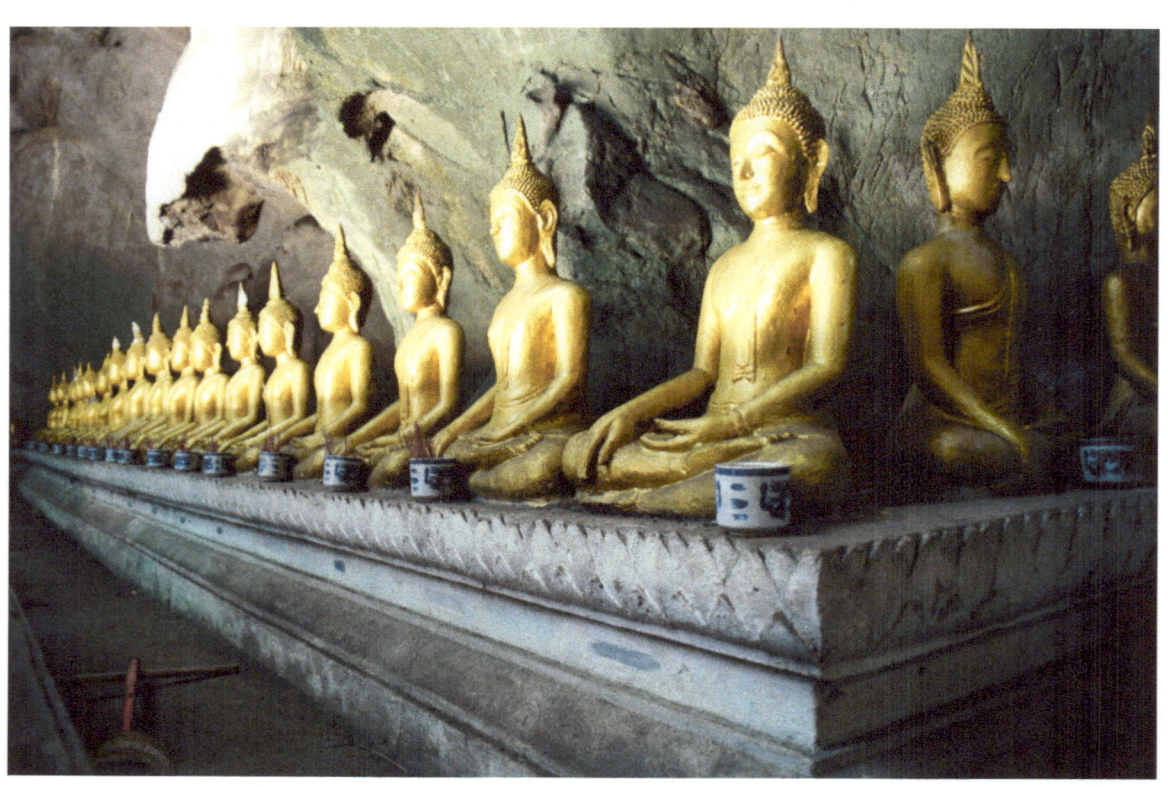

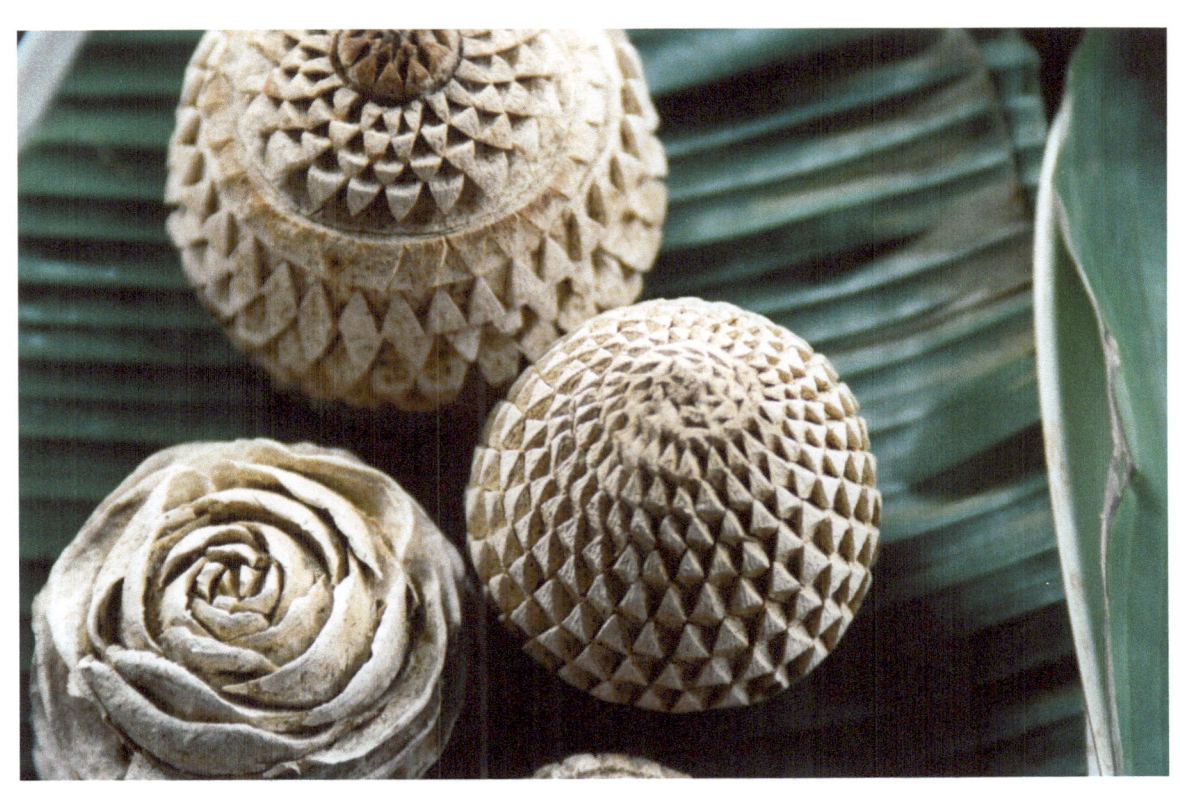

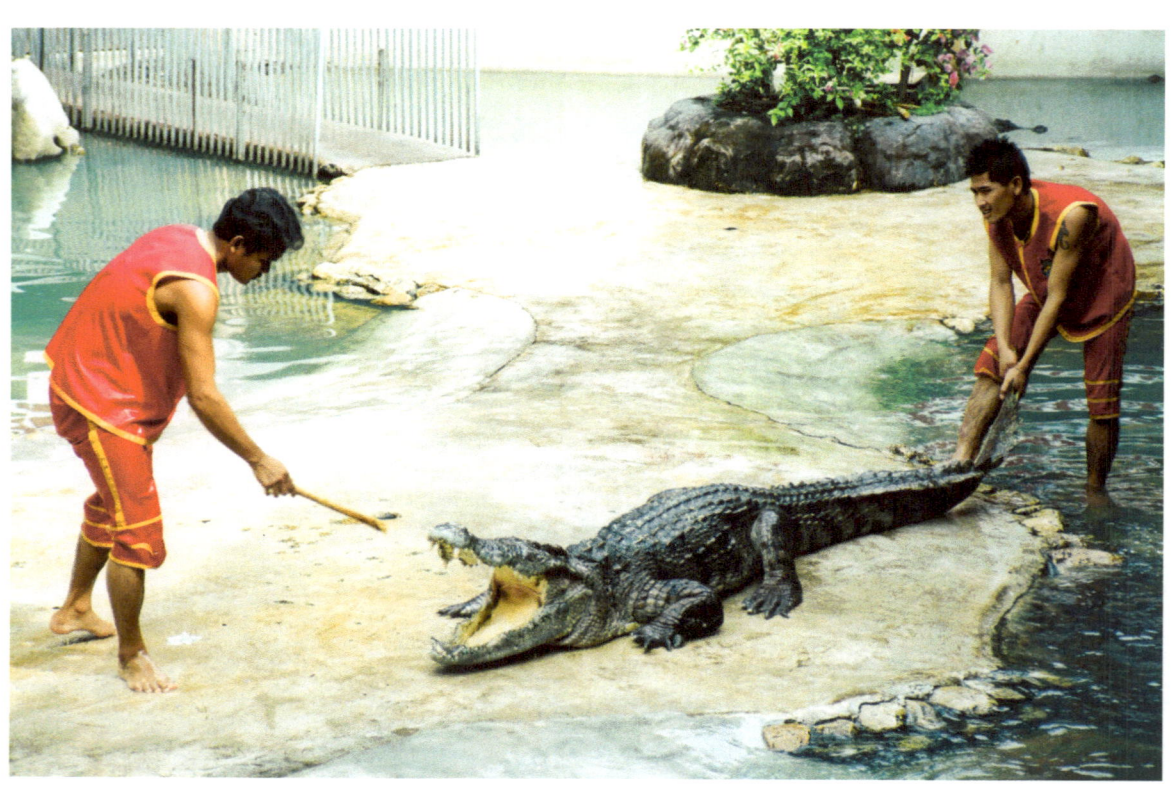

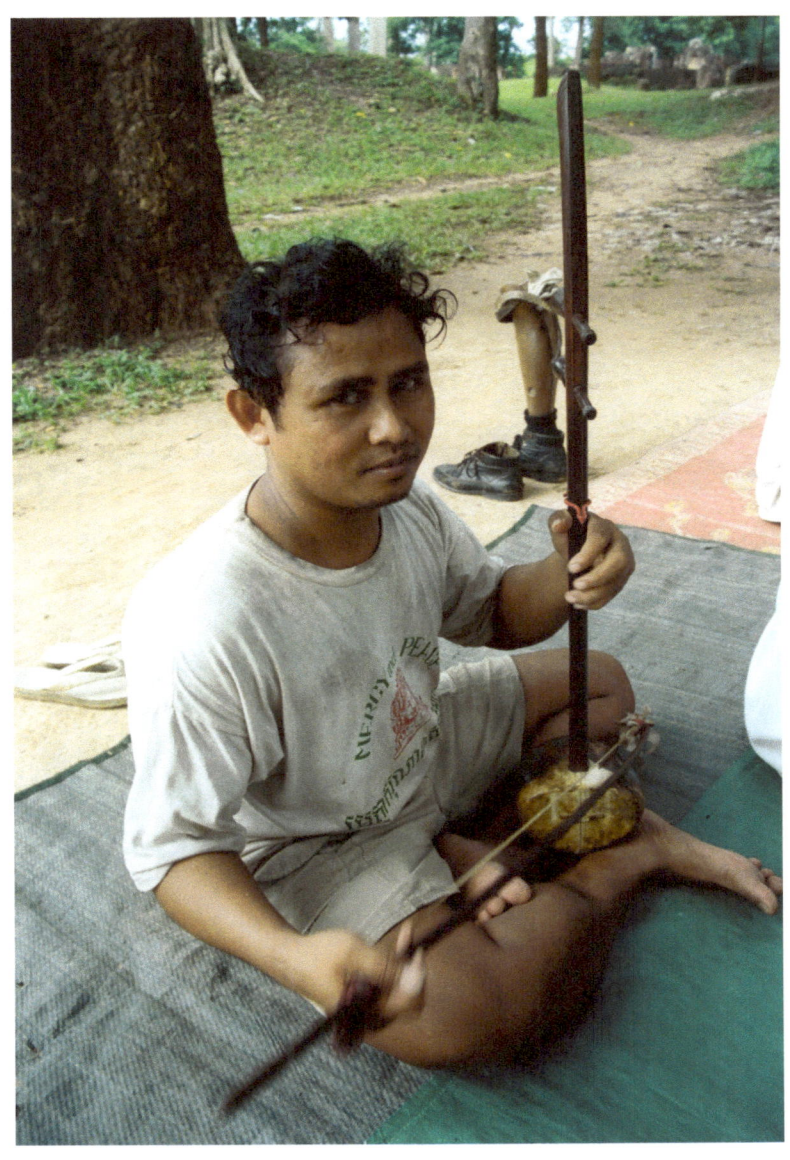

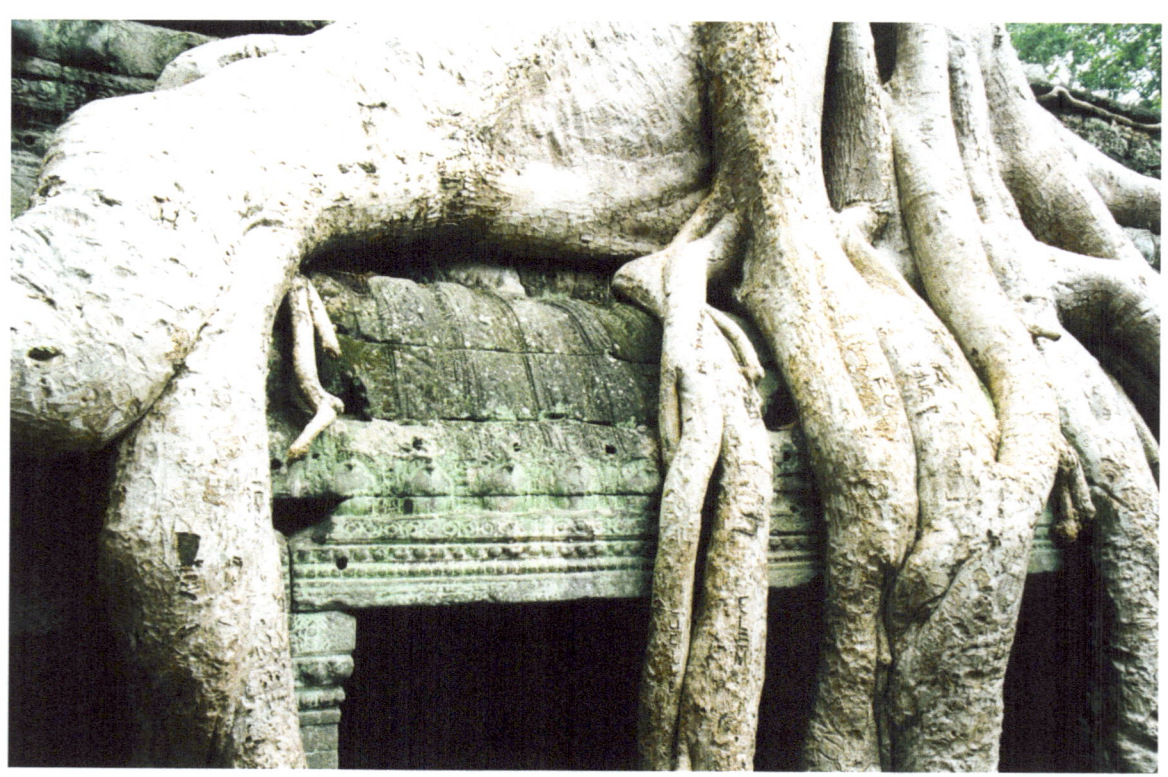

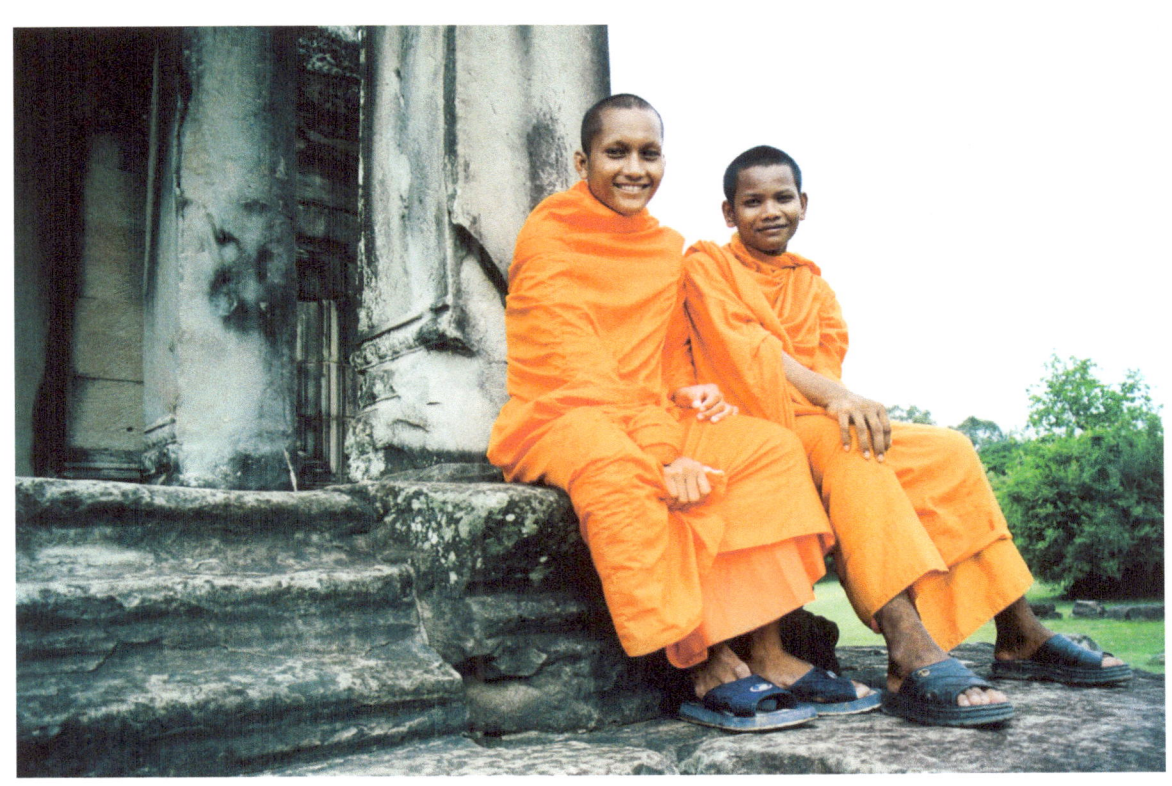

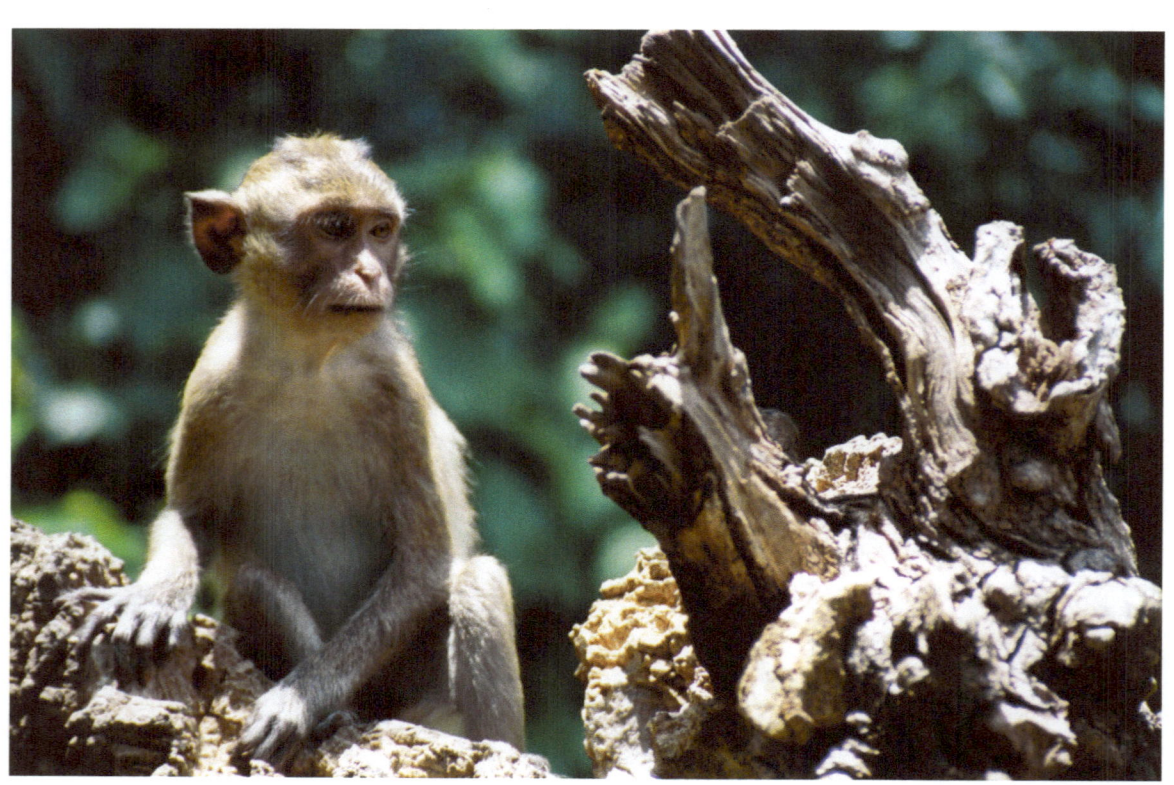

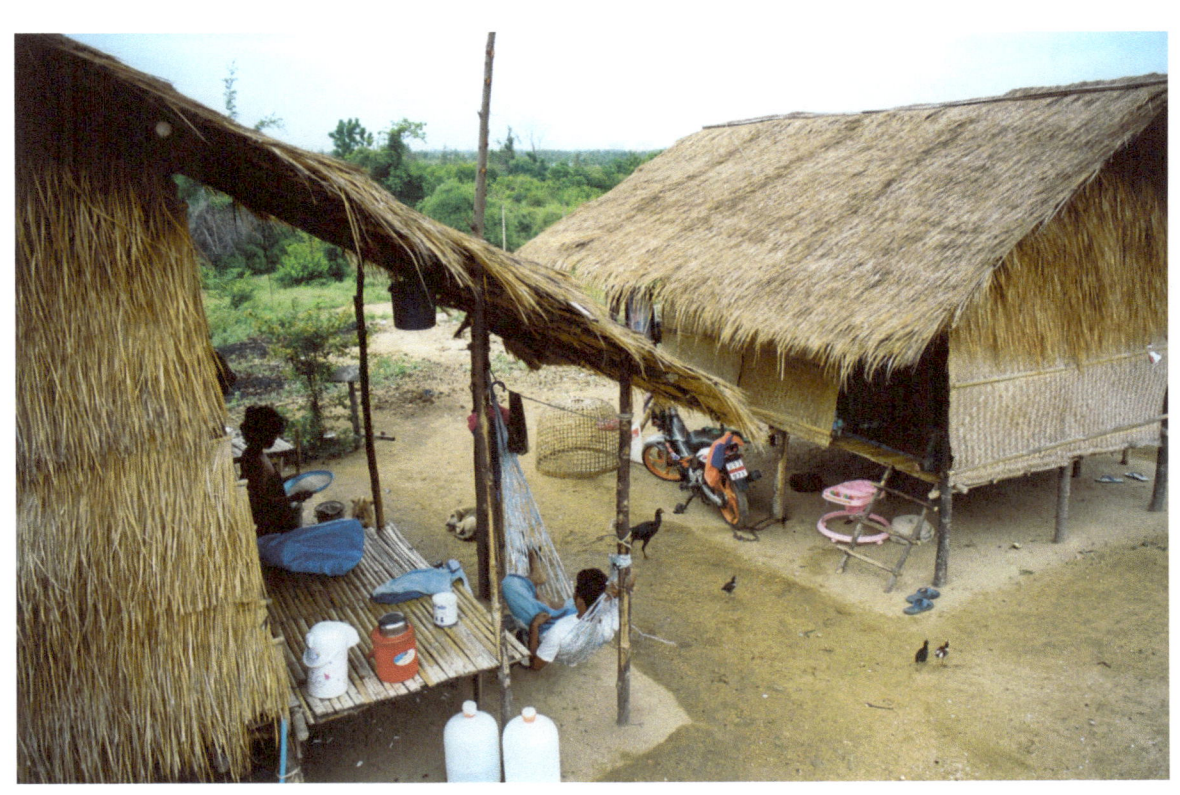

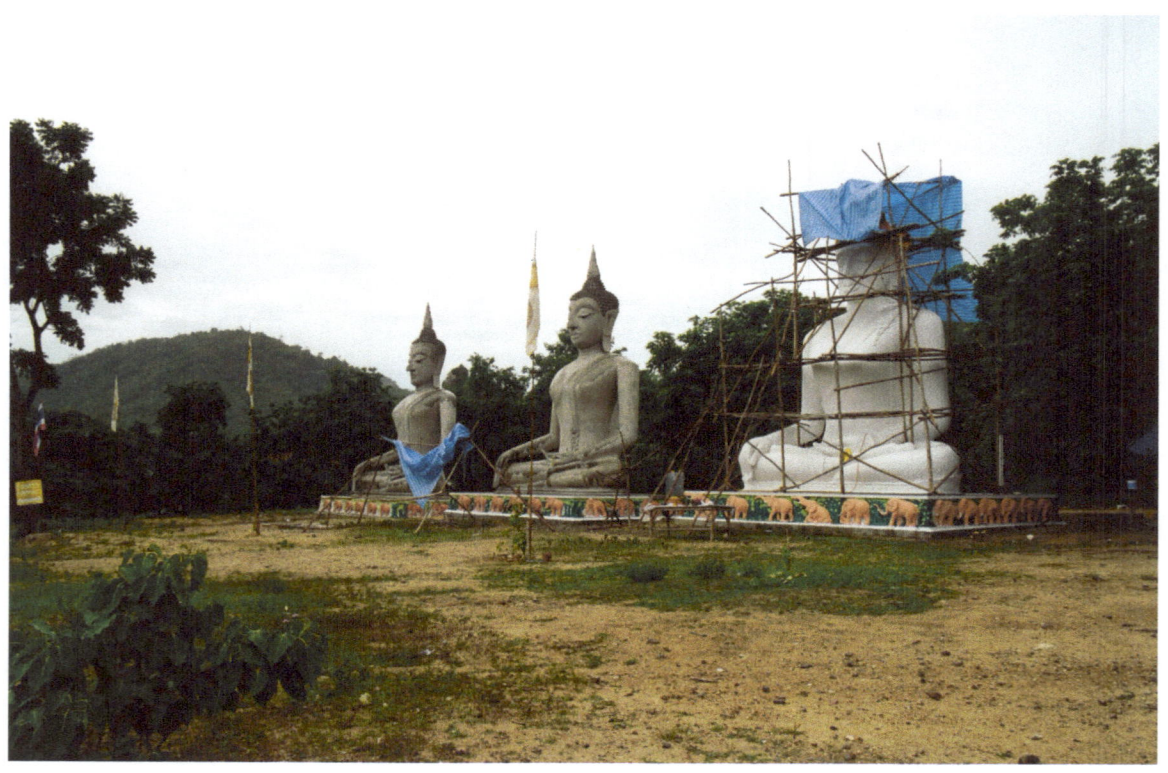

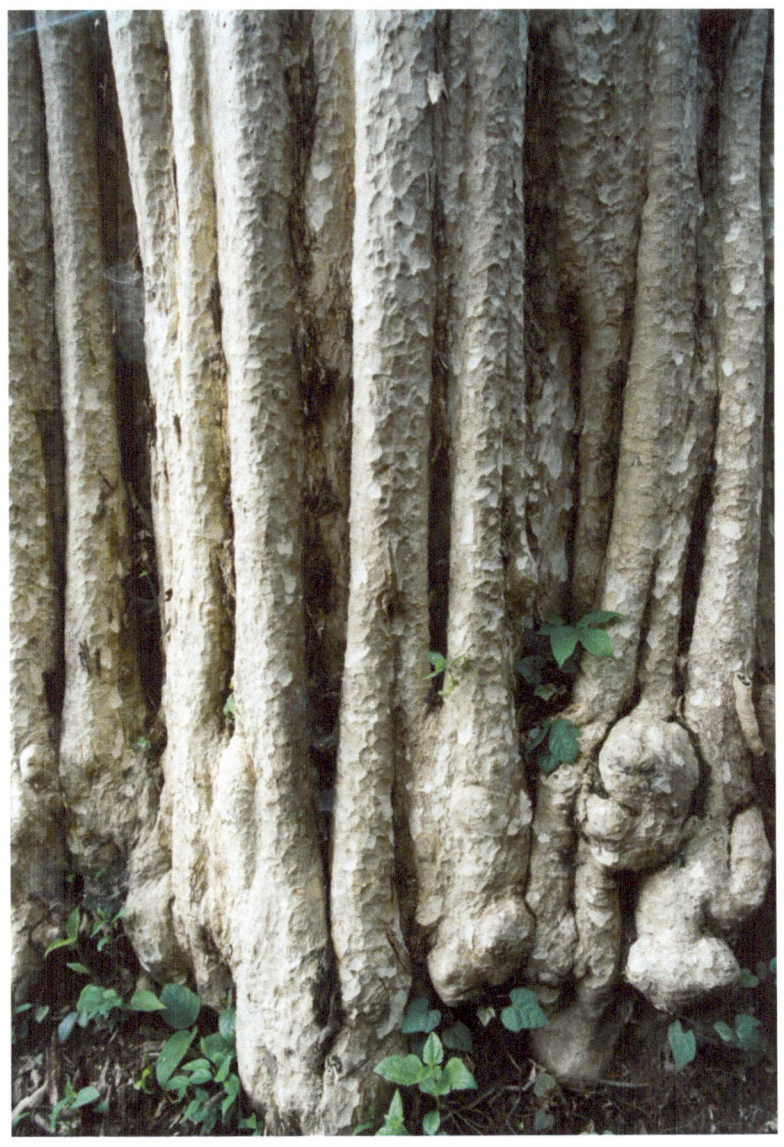

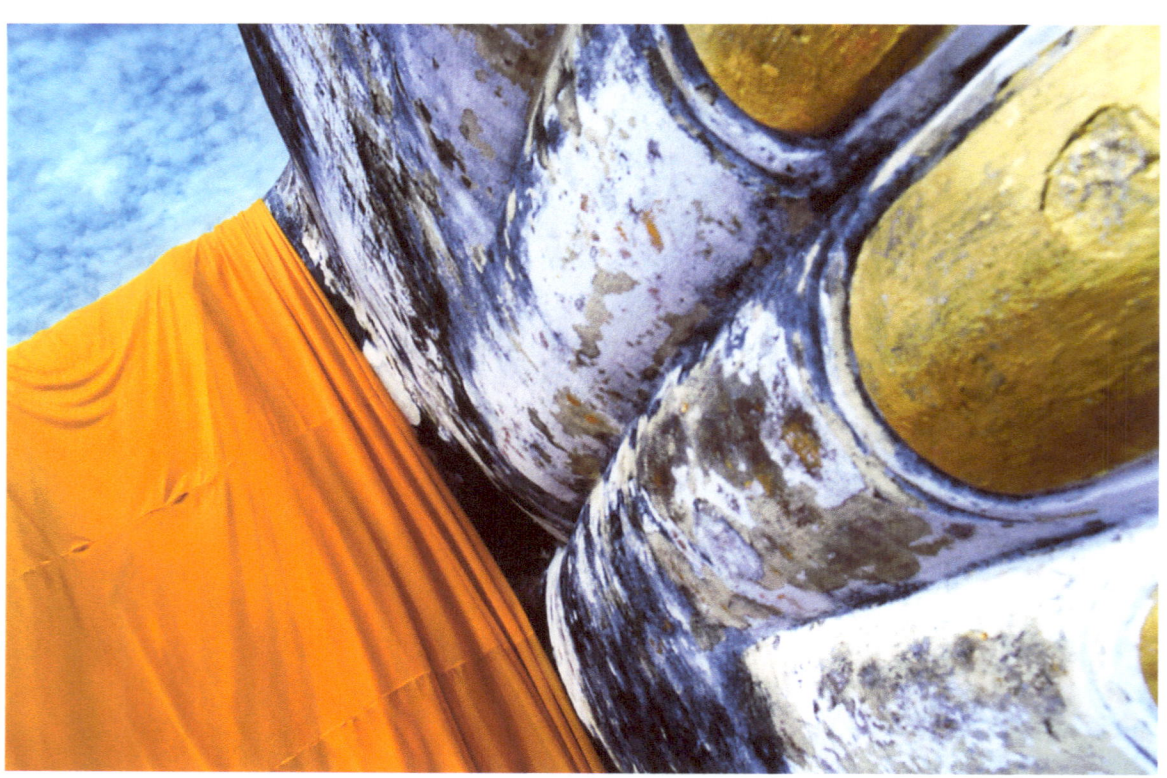

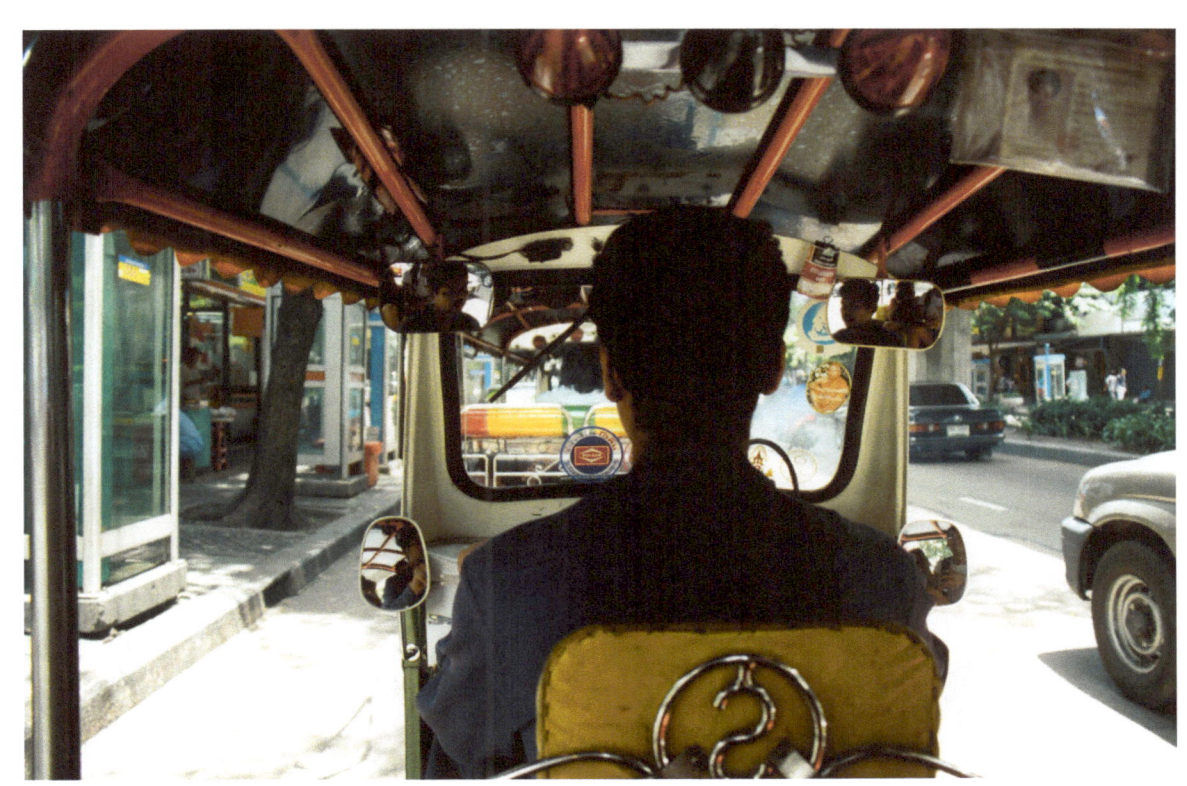

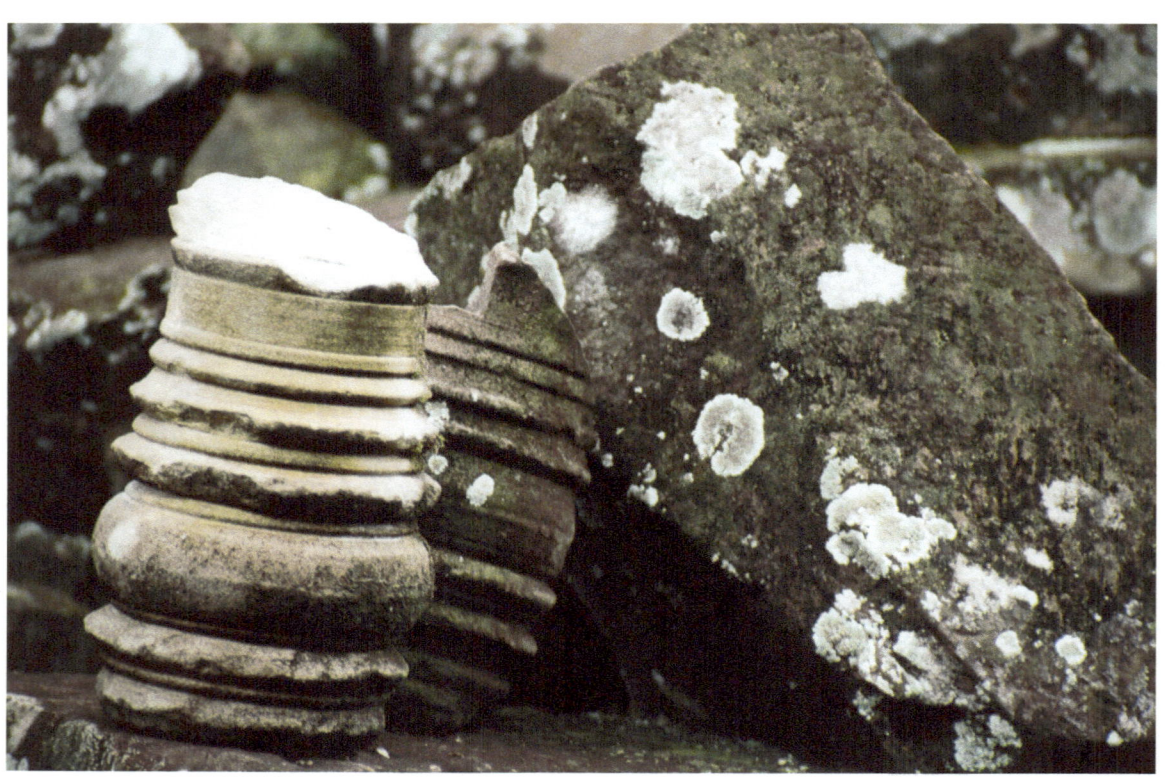

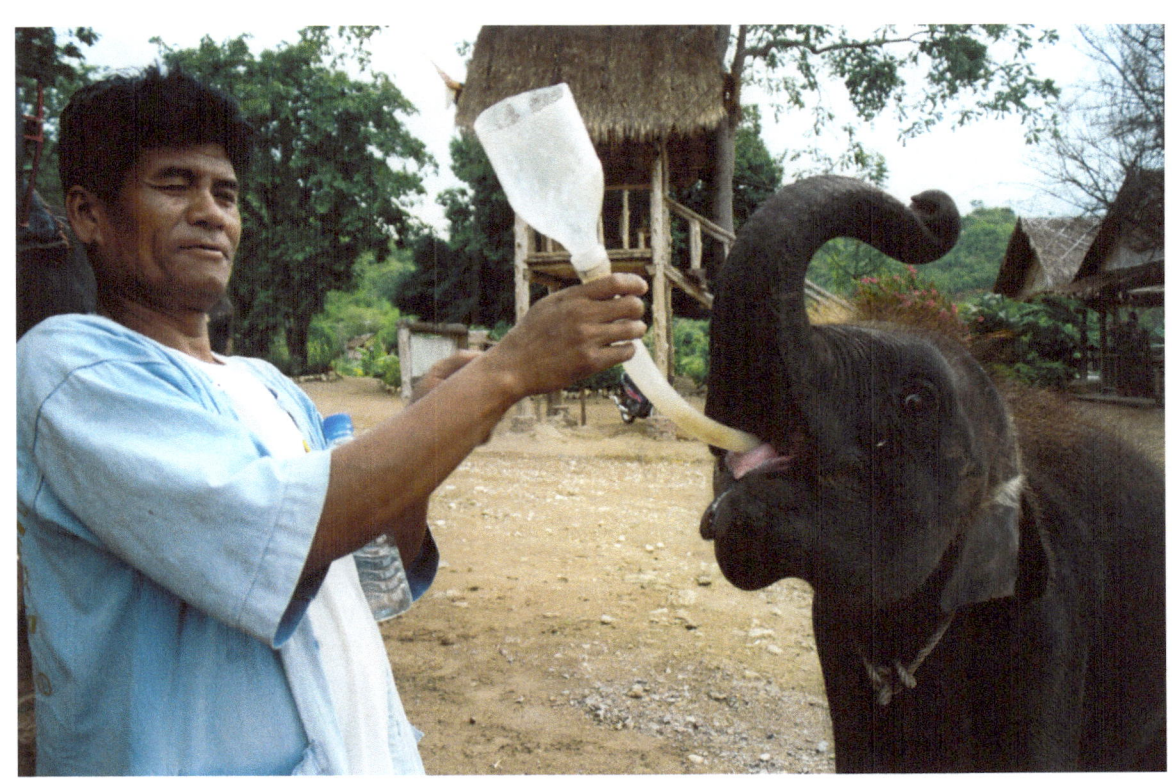

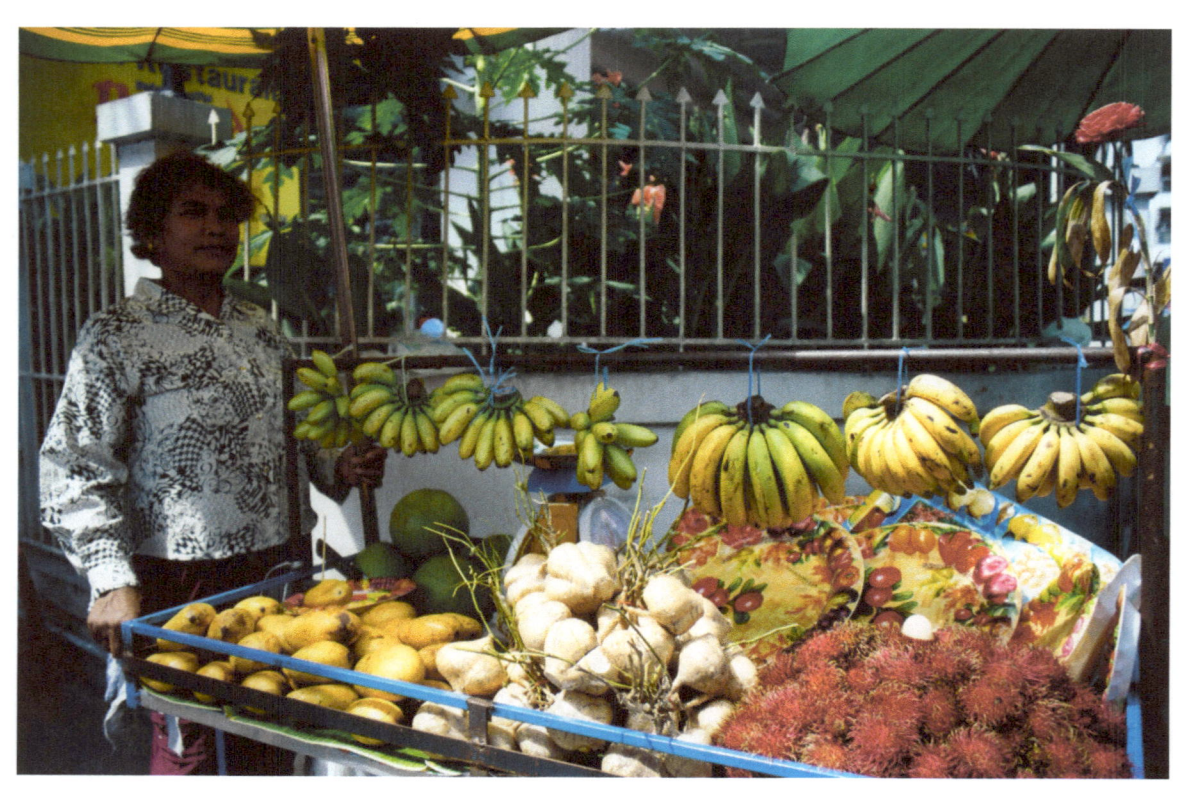

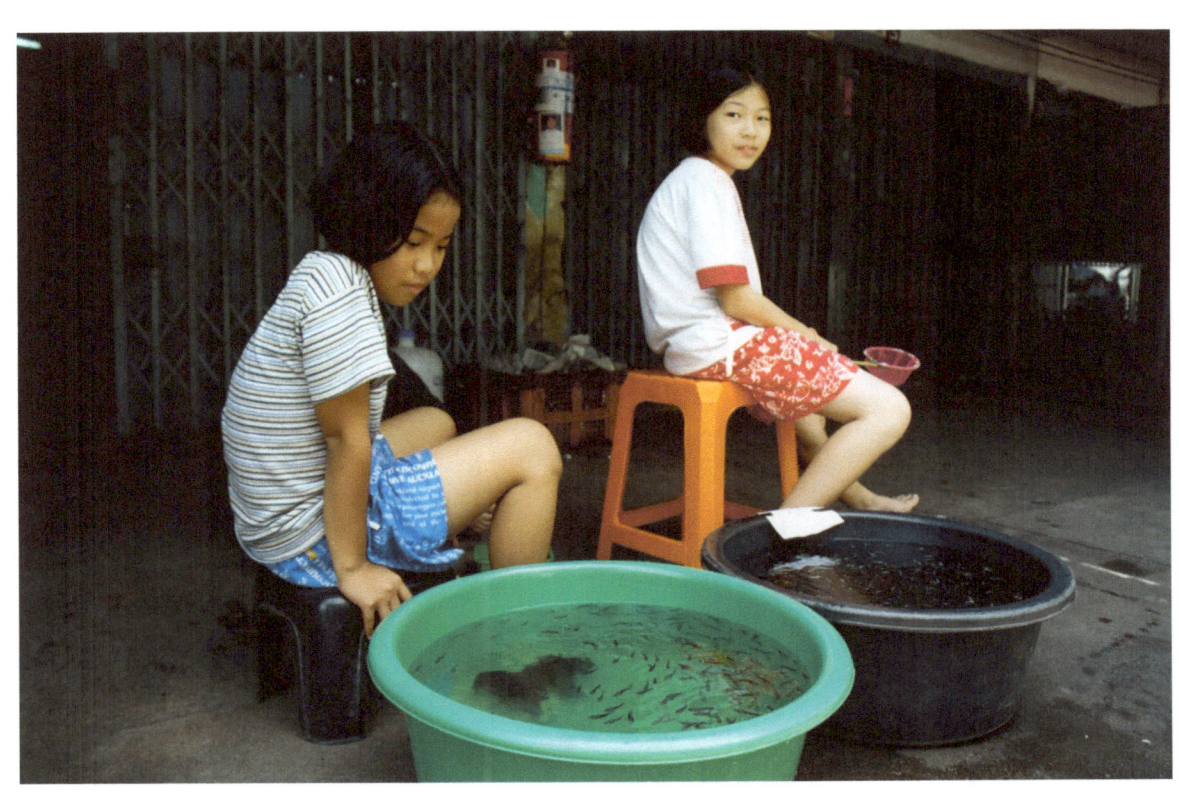

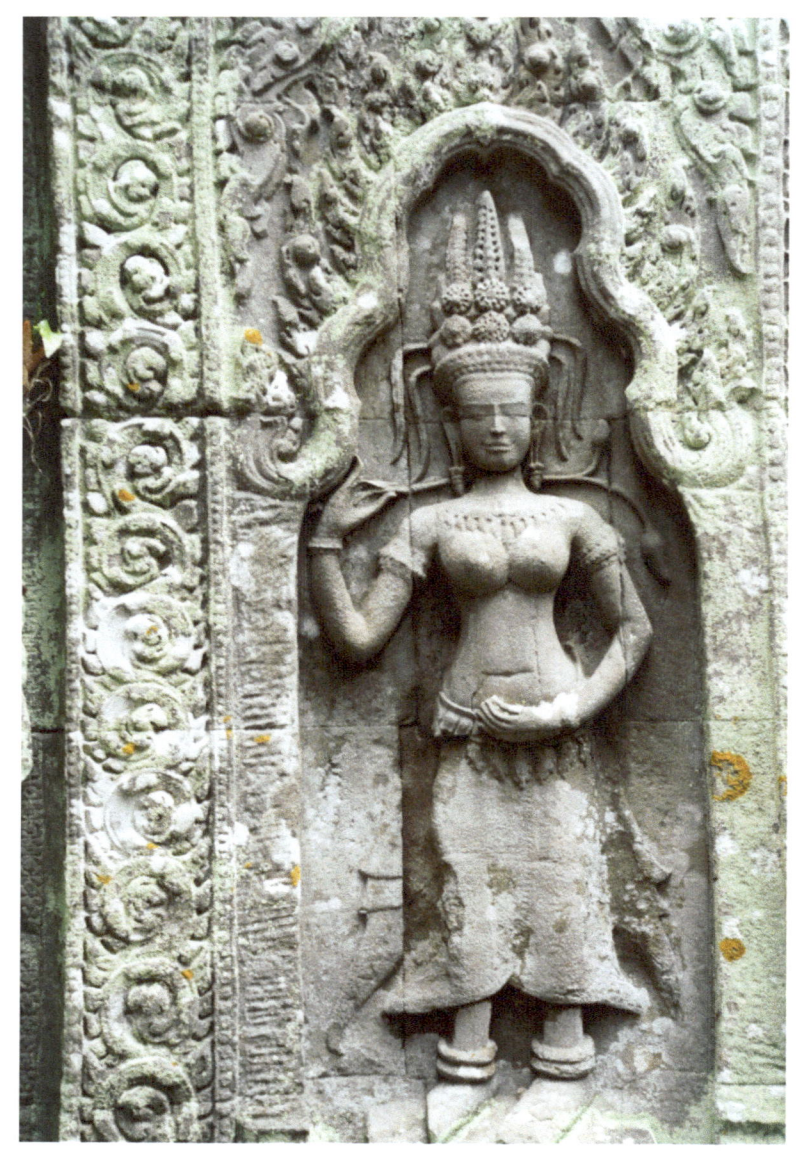

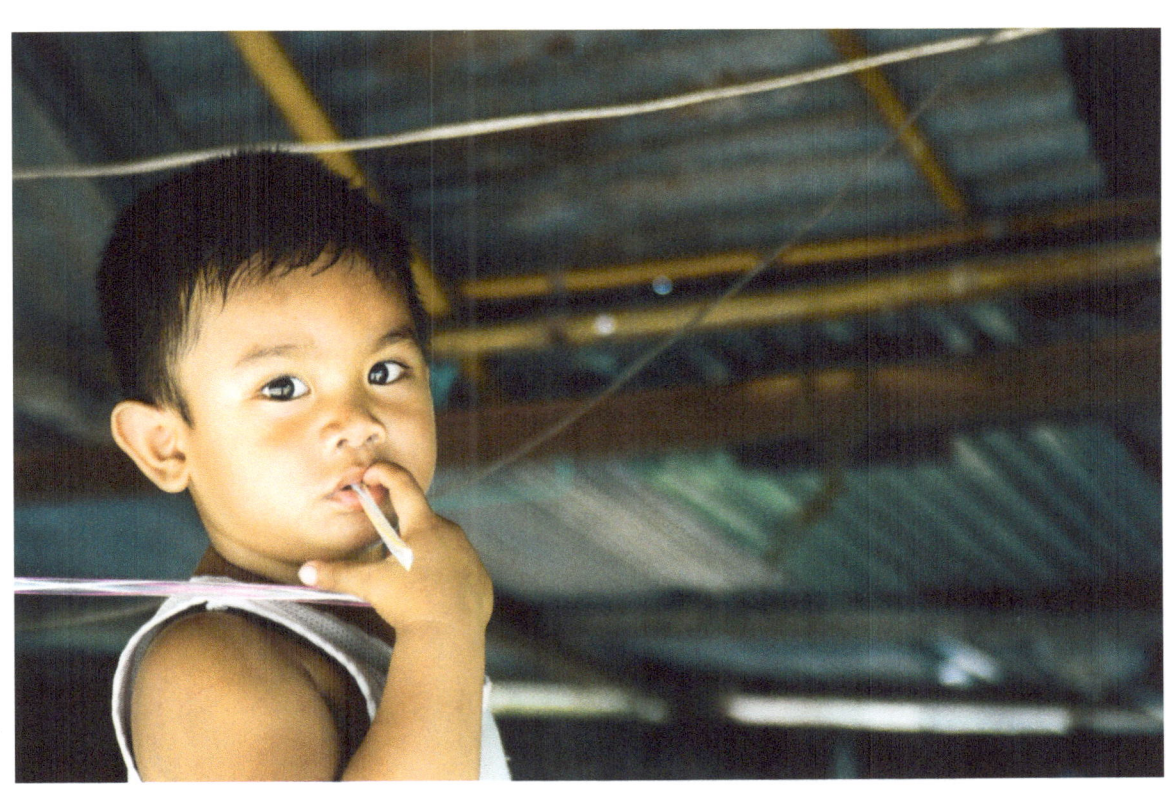

www.ingramcontent.com/pod-product-compliance
Lightning Source LLC
Chambersburg PA
CBHW051053180526
45172CB00002B/618